Sacramento

CHRONICLES

A GOLDEN PAST

Cheryl Anne Stapp

THE
History
PRESS

Published by The History Press
Charleston, SC 29403
www.historypress.net

First published 2013

ISBN 978-1-5402-0692-3

Library of Congress CIP data applied for.

Contents

CONTENTS

Acknowledgements

R esearch is the key to any history. I wish to thank the many dedicated professionals who gladly helped me find that exciting nineteenth-century personal diary or document, interesting story or solid statistic: the librarians and aides at the California Room, California State Library, Sacramento; the devoted staff at the Center for Sacramento History (formerly Sacramento Archives and Museum Collection Center); librarians at the California Secretary of State Archives; the staff and volunteers at the Old Sacramento Foundation; the learned contributors to the Sacramento County Historical Society's prestigious *Golden Notes*; the employees at the Sacramento County Recorder's Office; volunteers and staff at the California State Railroad Museum and California Military Museum; the helpful people at the University of California Cooperative Extension for their research into Sacramento hop ranches of bygone years; and the very knowledgeable history staff and volunteer docents at Sutter's Fort State Historic Park.

Before There Was a City

SPANISH-MEXICAN RULE

For thousands of years, the immense Sacramento Valley, where two great rivers joined to flow to the Pacific Ocean one hundred miles distant, was an untamed wilderness inhabited by only indigenous family tribes who harvested the abundant nuts and berries and fished in the clear waters. From time to time, the two rivers, swollen by rain and snowmelt, overflowed across the valley floor. When this happened, the natives simply retreated to higher ground until the deep floodwaters receded.

The indigenous peoples were unaware, in AD 1520, that their homeland suddenly "belonged" to an outsider when Spain claimed ownership, by right of conquest, of Mexico and most of the southern North American continent. European folklore arising from a popular novel insisted that the upper-westernmost portion of Spain's New World was a large island named California, ruled by Queen Calafia, a fierce black female warrior who carried spears and shields made of gold. Spanish seafaring explorers discovered the truth about 1540 (although the island concept lived on in European cartographers' depictions much longer) but nevertheless retained the mythical island's name. Alta (or Upper) California—the mainland directly above Mexico's Baja Peninsula—was bounded on the west by a dangerous ocean and on the south by man-killing deserts. Unimpressed with what appeared to be an inhospitable terrain with nary a gleam of gold

in sight, the conquistadores turned their attention to the development of Mexico and present-day Texas, Arizona and New Mexico. Alta California was largely forgotten for another 230 years.

Forgotten, that is, until King Carlos III learned that foreign ships were nosing about in the Pacific Ocean, even dropping anchor here and there along the shoreline of his completely undefended province. The crown's solution, in this eighteenth-century age of religious zeal, was to finance a contingent of priests to establish a presence, convert the native heathens to the Catholic Church and—through pious example combined with various types of vocational training—mold them into stalwart Spanish citizens. The priests would be accompanied by a military escort that would, in turn, erect *presidios* (forts) to thwart invaders.

In 1769, Father Junipero Serra arrived in San Diego Bay accompanied by his fellow monks, a band of soldiers and Don Gaspar de Portola, Governor of the Californias. Portola established a capital at Monterey Bay, and over the next fifty-four years the padres established twenty-one self-sustaining mission churches along the coast from San Diego to Sonoma. Some of the soldiers who came with Father Serra brought their wives; others married Indian women who worked at the missions. To further colonization, Spain granted vast tracts of land for cattle raising, called *ranchos*, to notable citizens as political favors or other rewards. The descendants of these pioneering families called themselves *Californios*, legal citizens of Spain (and later Mexico) who were born in California. *Pueblos*, or towns, grew on the outskirts of the mission properties. The Indian population, decimated by white men's diseases, declined.

Spain held its conquests for over three hundred years, until Mexico won its independence as a republic in 1822 and took control of all the former Spanish lands south of the forty-second parallel between the Pacific Coast and today's eastern boundary of Texas.

In all that time, not one Spaniard or other European settled in California's northern central valleys, although intermittent exploring parties found and named the region's major watercourses.

Meanwhile, however, a foreign nation brazenly established an outpost on the coast near Bodega Bay in 1812. The Russians named their colony Ross, an archaic name for their motherland. Their purpose, they explained, was simply to produce food in an agreeable climate for their snow-ridden outposts in Alaska. Contrarily perceiving the fortified enclave as a fortress, the Spanish nevertheless confined their protests to diplomatic maneuverings and grudgingly agreed to trade on a restricted basis. Mexican authorities,

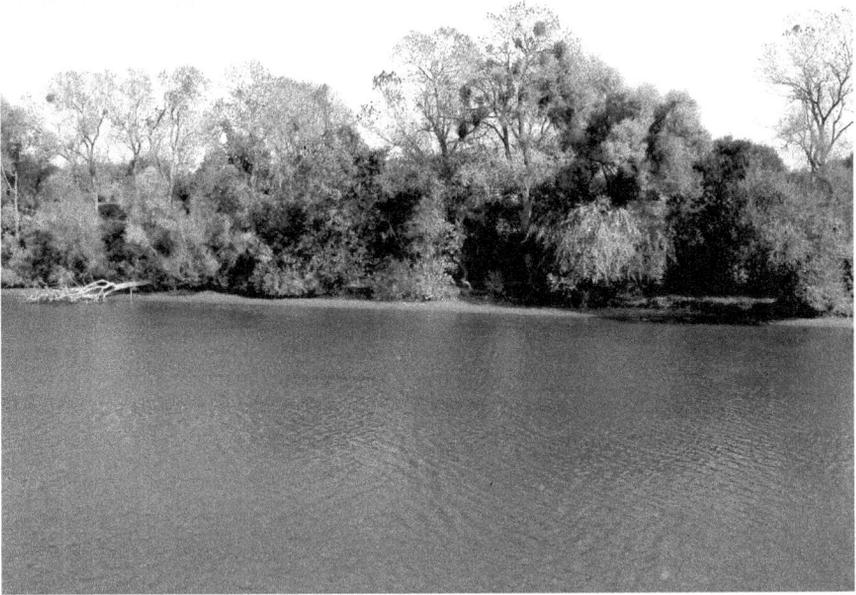

The Sacramento River south of downtown Sacramento. *Photo by author.*

with even fewer financial and military resources than their predecessors, continued to keep watch on the coast but also neglected the inland regions. In 1838, an American named John Marsh acquired ranchlands at the base of Mount Diablo, still many miles west of the Sacramento Valley.

Finally, in 1839, an immigrant appeared who actively desired to establish a settlement in California's interior, near the confluence of the Sacramento and American Rivers.

THE FIRST SETTLER

Swiss immigrant Johann August Sutter, filled with dreams of building an empire in the wilderness, landed his little fleet of three vessels on the American River near the foot of modern Twenty-eighth Street in mid-August 1839. He was accompanied by a crew of four Europeans and ten Hawaiians recruited during his roundabout sojourn in Honolulu, five sailors hired at the

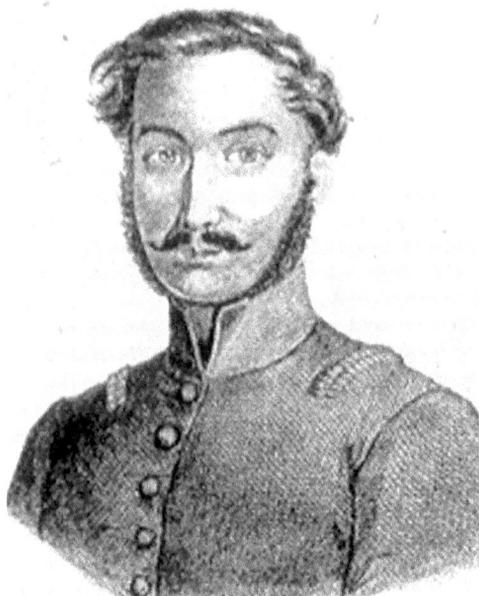

Johann August Sutter in 1835, age thirty-two. *Courtesy Sutter's Fort State Historic Park, Sacramento.*

little mud shack village in San Francisco Harbor, a servant and a bulldog. The entire party was immediately assailed by a voracious cloud of mosquitoes; the next day, six of the adventurers sailed back to the bay. Sutter and his remaining followers took the supplies and tools procured from an American trader in Honolulu to higher ground about a mile south, set up tents and island-style tule huts and commenced building more permanent structures. Whether he knew it then, Sutter's chosen site was the most strategic location in the interior, the key point of the most important routes north, south, east and west— the gateway that in coming years would prove vital for American possession of California.

Within eighteen months, Sutter received title to eleven leagues of the fertile Sacramento Valley—nearly fifty thousand acres—from Governor Juan Alvarado on the condition that he become a Mexican citizen, embrace the Catholic faith, erect improvements and bring twelve families to settle on the grant he named New Helvetia (New Switzerland). In addition to the land grant, Alvarado appointed Sutter as a representative of the government and agent of the law on the northern frontier, an appointment the governor made in the hope that Sutter might bring an end to cattle- and horse-thieving raids against coastal settlements perpetrated by marauding Indians from the interior.

Luckily for Sutter, the first band of Indians he encountered included two mission runaways who spoke Spanish, a language Sutter was familiar with from his trading days in Santa Fe, New Mexico. Through their chieftains, Sutter arranged to employ dozens of Indians as field hands, livestock tenders and his own armed personal guard. He paid them in trade goods, redeemable with a tin disk stamped with the number of days the individual

had worked. Using this Indian labor, Sutter erected a large trading post compound of hand-formed, sun-dried adobe brick. Its walls contained living quarters, offices, storage and shop space for the blacksmiths, coopers and other skilled craftsmen he quickly attracted from the ranks of sailors, trappers and adventurers who entered pastoral California. From established ranchers Antonio Suñol near San Jose, Ignacio Martinez on Suisun Bay and Mariano Vallejo in Sonoma, he acquired horses, cattle, sheep and pigs, establishing a sheep and hog farm near the southeastern edge of present-day William Land Park. He set up a tannery to process cattle hides, embarked on a salmon fishery enterprise and planted crops.

By all accounts—even those of his detractors—John Sutter was a handsome, well-read, charming, energetic and ambitious individual. He spoke Swiss-German, French (the international language), English and Spanish. His polished manners and consistent polite address were character traits not usually found in frontier environments. Captain John Sutter was beloved and revered by hundreds of weary, and sometimes destitute, immigrants for his selfless gifts of food and shelter. He was despised by scores of *Californios* for his insufferable insistence on complete independence, his demands for more stock and supplies while skillfully evading payment for goods already delivered and a host of other impolitic transgressions. Sutter's most famous act of kindness is the aid he provided to the stranded, desperate Donner Party in the winter of 1846–47. Perhaps his most famous blunder (among many) was his support of the very unpopular Governor Manuel Micheltorena in a military campaign that the other side won.

Sutter was a poor businessman who often ignored the finer points of finances and was susceptible to the flattery of unscrupulous individuals. He neglected to mention to authorities that the reason he had come to the United States in 1834 was to escape clamoring creditors in his homeland or that his rank of captain in the elite Swiss Guards was a grand fabrication spun from a rather more limited military experience. He lacked adequate capital. Instead, his charisma convinced ranchers and merchants to sell him what he needed on credit. Acquiring goods in this manner was an established practice in cash-poor California, but Sutter angered his suppliers by paying slower than custom allowed or renegotiating the terms of payment altogether when he couldn't deliver the stipulated items. Sutter was not a crook; he intended to pay his debts. His pressing needs combined with a boundless optimism convinced him he would honor his obligations when his situation improved—in his mind, always a sure thing as soon as he recovered from whatever circumstance caused his current setback.

Such were his promises in December 1841 when the Russians decided to abandon their Bodega Bay colony, and Sutter—egregiously affronting Mexican officialdom, whose Spanish antecedents had never given the Russians leave to settle on *their* land in the first place—purchased the moveable assets of Fort Ross: buildings and fences, livestock, tools, furniture, boats, saddles, glass windows and dozens of other much-needed commodities. It was his most audacious bargain to date, committing him to pay $30,000 over four years—the first three years in wheat, vegetables and tallow, with the final payment of $10,000 due in coin, a prodigious amount of cash at the time the agreement was signed. The Russians demanded a mortgage on New Helvetia as security, and now, infuriated though they were, the Californios dared not evict the impertinent lord of New Helvetia. For one thing, their intertwined house-of-cards barter system might collapse if Sutter departed without honoring his debts. For another, what might happen if the Russians took over New Helvetia and established a military presence at such a strategic location?

Successive droughts and the Mexican-American War of 1846–47 interfered with his ability to deliver on his Russian debt, but Sutter, ever optimistic, fastened on another plan to improve his holdings and raise cash

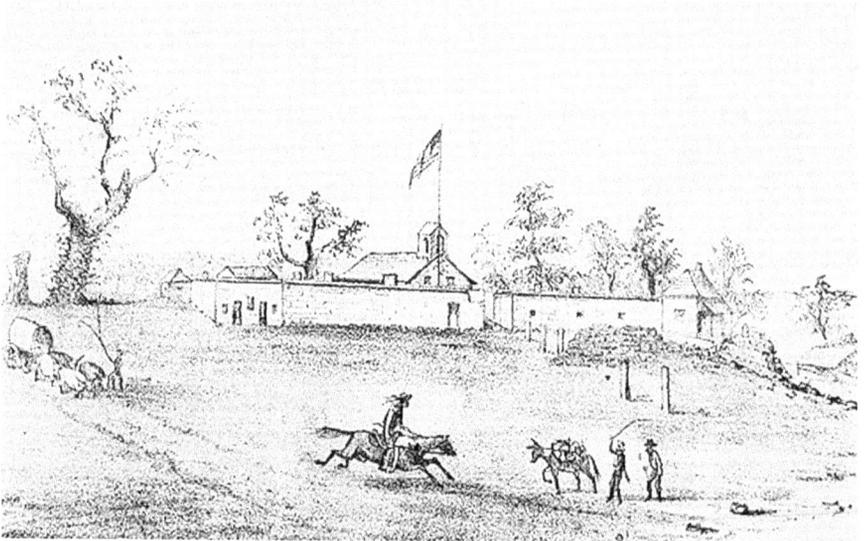

Sutter's Fort south-facing exterior walls and main gate, circa 1844. *Courtesy Library of Congress HABS CAL, 34-SAC, 57—3.*

at the same time. He needed lumber for the many continuing projects about his fort and to sell to arriving settlers for housing, but lumber was an expensive commodity. He decided to build his own sawmill near a supply of standing timber. In late August 1847, Sutter's employee and experienced millwright James Marshall, accompanied by a crew of discharged Mormon Battalion soldiers, left for the timber-rich foothills valley that the Indians called Coloma, forty miles east of New Helvetia. No one, least of all John A. Sutter, ever dreamed that this practical need and straightforward solution would catapult him to global fame as the agent, if not the actual discoverer, of the gold that electrified the world.

The mill was still unfinished on the morning of January 24, 1848, when James Marshall found a few gold particles at the bottom of the mill's tailrace. Sutter and Marshall implored the mill hands to keep the find a secret at least until the project was complete, and they agreed, but within two months rumors lured skeptical-yet-curious locals to Coloma.

In May 1848, enterprising merchant Sam Brannan—who owned a mercantile outlet right outside the fort's gates and another in San Francisco—rode through the streets of that city brandishing a bottle filled with gold dust and shouting, "Gold on the American River!" Disbelief evaporated; the stampede began. Brannan's action effectively launched the gold rush and his own fortune.

By mid-year, thousands of fortune-seekers from Pacific Rim locales were mining in the rivers, streams and ravines. The Russians and others, who erroneously assumed Sutter must now be very rich, began pressing for payment while Sutter's crews abandoned him, leaving his grains unharvested and hides rotting in his tannery. His beloved New Helvetia was finished as an agricultural domain by June. In September, Sutter's twenty-one-year-old son, August, arrived from Switzerland, quickly becoming embroiled in his father's unhappy situation as opportunists appropriated whatever they wanted at the fort and creditors closed in. In an attempt to forestall threatened legal actions, Sutter transferred all his real property and livestock to his son in October and then rode into the mountains to try his hand at gold mining.

August, who remained at the fort, grew desperate to raise money to repay his father's debts, and he owned title to the New Helvetia grant. Well-meaning but malleable, August accepted the advice of shrewd Sam Brannan to create a new town in the angle made by the Sacramento and American Rivers, where Sutter's private landing place was the ideal debarkation spot for gold-seekers coming upriver from San Francisco. In December,

August (John Jr.) Sutter. *Courtesy Sutter's Fort State Historic Park, Sacramento.*

Captain William Warner, assisted by then-lieutenants William Tecumseh Sherman and Edward O.C. Ord, surveyed and mapped Sacramento City. Neither August nor the surveyors had personal knowledge of the area's vulnerability to inundation. John Sutter, who did, was snowed in at Coloma throughout the whole process. August hired lawyer Peter Burnett to sell city lots; Burnett held an auction in January 1849.

Sutter was furious when he returned, but it was too late. Merchants and saloon owners promptly erected tents and wooden shanties on the waterfront. Sacramento, geographically located at the gateway to the gold mines, sprang to life. Sutter and his reunited Swiss wife and three younger children removed to his Hock Farm on the Feather River, some sixty miles north of the new city. The funds from the sale of city lots freed Sutter of his debts, but the reprieve didn't last. Sutter reclaimed his unsold land titles from August, but gradually his old habits landed him in another financial morass. However, this did not diminish his unique status or widespread acclaim. Captain Sutter was a member of the delegation, and delivered the keynote address, at California's first Constitutional Convention in September 1849. He was nominated for governor, finishing third in a field of six candidates. In 1853, the state legislature elected him to the rank of major general of the California Militia, an unpaid, mostly ceremonial post that Sutter nonetheless treasured. General Sutter remained a sought-after, genial host to old and new dignitaries until an arsonist destroyed his Hock Farm residence in June 1865.

Sacramento's first pioneer left California for good six months later, to eventually settle and raise his grandchildren in Lititz, Pennsylvania, where

he is buried. John Sutter died in a Washington, D.C. hotel room on June 18, 1880. He was in the nation's capital for his fifteenth consecutive year of attending congressional sessions to personally press his petition for federal recompense, citing his part in "developing the mineral and agricultural wealth of California," plus losses sustained when the Supreme Court "unjustly rejected" his ownership claim of his second land grant (the Sobrante grant in 1845, which gave him approximately 100,000 additional acres from the American River north to the Sutter Buttes). His death came two days after learning that the Forty-sixth Congress had adjourned without passing the appropriate bill for his relief.

Part II

Sacramento Becomes a Vibrant City

GOLD RUSH DAYS

As John Sutter was leaving the area in March 1849, throngs of fortune hunters, collectively named Argonauts after the ship in the Greek tale of Jason's quest for the Golden Fleece, were arriving by land and sea in the greatest peacetime migration the world had ever known. The year 1849 alone saw nearly ninety thousand mostly young, predominantly male immigrants enter California, immediately and evermore dubbed the 49ers. Lisle's Ferry transported them across a three-hundred-foot span of the American River, replaced circa 1851 with Lisle's Bridge, a drawbridge constructed of lumber, located where the Sixteenth Street overpass stands today. Tens of thousands passed through Sacramento; an estimated nine thousand established residence, some temporarily and others longer-term.

Tents mushroomed between the trees south of the business district, which rapidly expanded with more substantial buildings. There was no developed agriculture or manufacturing anywhere in California; food and merchandise came from trading vessels, adding shipping rates on top of highly inflated prices for everything from onions to boots. Army captain Joseph L. Folsom reported to his superior in Washington, D.C., that common shoes worth seventy-five cents in Boston were selling for eight to twelve dollars in California. Whiskey flowed at the modern equivalent of fifty dollars per glass, dispensed in great quantities from saloons and gambling

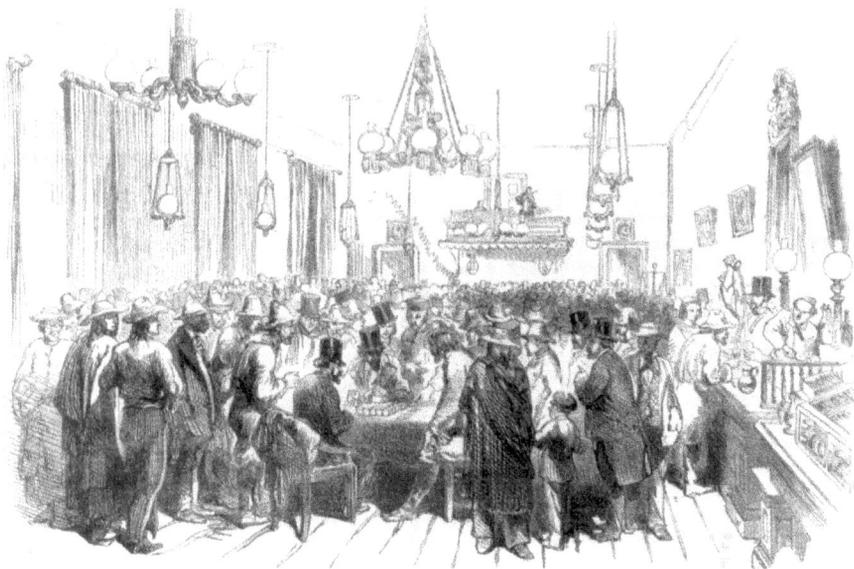

A saloon and gambling house in Sacramento's gold rush heyday. *Courtesy Library of Congress Illus. in AP4.13 (General Collections).*

dens on every Sacramento street corner. Infamous establishments like the Stinking Tent, the Diana, the Gem, the Empire and the Plains, which adorned its walls with frescoes depicting familiar scenes along the overland trail, were constantly crowded. Gold miners tramped through town day and night, often carelessly leaving gold-filled pouches untended—and unmolested—near their beds or under merchants' counters. The American Hotel on K Street advertised, "Rest for the Weary and Storage for Trunks." The sounds of music, quarreling voices and clattering hooves wafted through the air, as did the odors of cigar smoke, campfires and spilled whiskey. There was only one public bathhouse. Roving cattle sometimes poked their heads through open windows.

Scores of unsuccessful, disappointed miners returned to their hometowns, having "seen the elephant," an expression used as an all-around metaphor for an exciting, unequaled experience fraught with potential misfortune. More replaced them. Others saw an opportunity to reap a bigger, surer fortune by establishing mercantiles, hotels, foundries, shipping lines, bakeries, brickyards and breweries. Married men who decided to settle permanently sent for their families, sometimes with a delay of two or more years while the men solidified or expanded their business endeavors. Sacramento, second in population only to San Francisco, grew.

Sacramento Becomes a Vibrant City

The price of real estate soared, driven by genuine desire to own property for homes and businesses and by wild speculation. City lots that August Sutter's agent, Peter Burnett, sold at auction for $250 in January 1849 were selling for $3,000 by the end of the year. Lenders demanded, and got, 10 percent interest *per month*. In the frenzy, unscrupulous parties too often sold the same parcel two or three times to different buyers, recording the sales late or in haphazard fashion. The result was chaos. Settlers who arrived later were outraged to discover that land they had purchased in good faith from one seller had to be paid for again when another owner surfaced, claiming title. Compounding the issue, the debt-burdened city twice imposed retroactive property taxes during the 1850s, forcing landowners to remit "unpaid" taxes or else lose their property at a duly posted sheriff's sale. Sacramento's first financial crash occurred in 1850, creating ruin for some but opportunity for others.

Nonetheless, Sacramento was booming. It was a rough town with few frills but eager to import the amenities of East Coast civilization. A post office was established in July 1849 aboard the bark *Whiton*, anchored on the Sacramento River. Schooners transported the mail to San Francisco or riders carried it on horseback. The Eagle Theater opened to cheering crowds. The *Placer Times* began publishing in 1849, succeeded by the *Sacramento Transcript* from 1850 to 1851. The *Sacramento Union*, which would last through 1994, presented its first issue on March 19, 1851. The *Sacramento Daily Bee* made its debut on February 3, 1857. In the style of the era, "news" was printed on inside pages, while the front page carried advertisements, transcripts of court cases, proposed legislation and the occasional short story.

James McClatchy, a journalist for the *New York Tribune*, settled in Sacramento in the late summer of 1849 after a few weeks of unsuccessful gold prospecting. He wrote for the *Placer Times* and was active in community affairs. Between 1850 and 1856, McClatchy edited, part-owned and/or founded four more short-lived Sacramento newspapers. He contributed to the *Bee* from its inception, becoming the paper's editor in July 1857. Six years later, he was elected Sacramento County sheriff, returning to his editorial desk after a successful two-year term. Over time, he gradually bought the interests of the *Bee*'s owners; by 1876, James McClatchy & Co., in partnership with John Francis Sheehan, owned the newspaper. James McClatchy remained an influential voice in the political and social life of Sacramento until his death in 1883, when his heirs purchased Sheehan's interests. The family-owned *Sacramento Bee* is still in circulation.

Gold lured all manner of business enterprises. Two short years after August Sutter commissioned a division of New Helvetia lands into city lots,

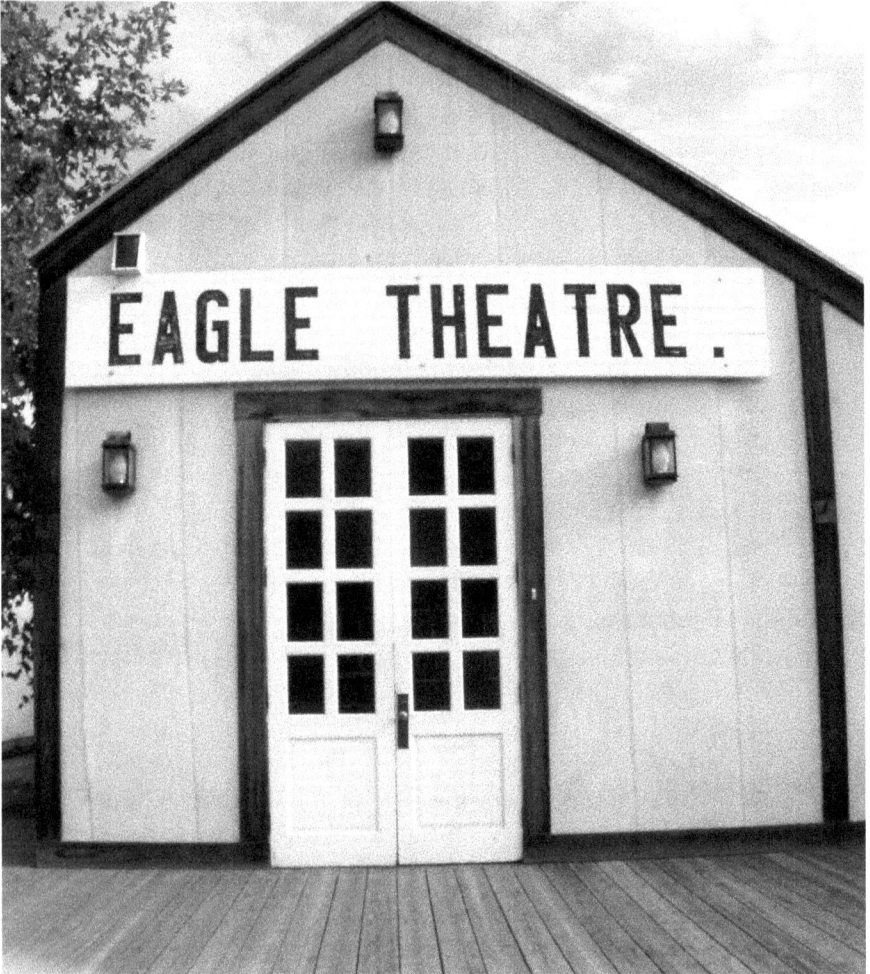

Replica of Sacramento's first theater, destroyed in the 1849–50 flood. *Photo by author.*

Sacramento boasted two flour mills, a foundry, a local dairy, a candle and soap factory, skilled artisans (from blacksmiths to cabinetmakers to wallpaper hangers), jewelers, bookstores, pharmacies and specialty marketplaces. B.F. Hastings & Company, D.O. Mills & Company and Adams & Company provided banking services from impressive new facilities, with Adams & Company dominating the overland gold transport business until the arrival of Wells, Fargo & Company in 1852 (originally only an express service). By 1854, six flour mills, among them the Phoenix Milling Company, were spewing smoke into the air as they produced nearly 585 barrels per day to feed city residents and gold miners in the hinterlands. In 1913, Phoenix constructed

a new five-story mill at Twelfth and C Streets, selling it six years later to the Globe Milling Company of San Francisco. Pillsbury purchased the expanded Globe Mills complex in 1940, operating until 1968, when it closed the plant. After forty years of dormancy, the multistory plant was redeveloped as housing. The Lofts at Globe Mills is a City of Sacramento landmark.

During and after the gold rush, immigrants from the Atlantic states brought their standardized weights and measures, social values, legal and governmental systems and benevolent institutions. East Coast members of the Masons, the Independent Order of Odd Fellows and the Sons of Temperance had all organized Sacramento chapters by the end of 1849. The Masons and Odd Fellows Hospital, originally located at Sutter's abandoned fort, was established by the two fraternal orders in a common effort. Doctors John Morse and Jacob Stillman opened another hospital on Third and K in December 1849, announcing reduced prices for needy patients.

The Sacramento River, flowing from headwaters in the shadow of Mount Shasta and therefore tying the city to both San Francisco and points north, was the most important transportation corridor in the state. By 1852, Sacramento was such an important transportation and commercial hub that 363 sailing ships and 238 riverboats called at Sacramento's docks that year alone.

Women were scarce—less than 7 percent of Sacramento's inhabitants in 1850. Their numbers did increase but never matched counts of male inhabitants throughout the ensuing decade. Five years into cityhood, on April 28, 1854, readers saw the following in their morning *Sacramento Daily Union*:

> *An acquaintance who…volunteered to "watch store" for a friend on J Street…thought he would ascertain how long it would be before 100 persons passed the door. One hundred persons passed in six minutes, equal to 1,000 per hour. Of these, six were women…there passed during the same time twelve horses and mules; five drays; one wagon and one horseman.*

Much complaint about the condition of Sacramento streets—dust-choked in summer and impassable muddy quagmires in winter—resulted in an 1853 project to plank downtown streets with thick, twenty-eight-foot-wide lengths of Oregon fir, a fix that didn't last. That same year, telegraph wires connected Sacramento with Marysville, San Francisco, San Jose and Stockton, but there was no telegraph service connecting with the eastern United States until 1861. Artesian well drilling through gravel and hardpan was difficult for early Sacramento settlers, and water from shallower-depth wells was foul tasting. The city waterworks opened on Front Street in 1854,

Replica of an 1800s boathouse at the Sacramento riverfront, Old Sacramento. *Photo by author.*

piping water from the river through rooftop tanks directly to kitchen pumps, so long as they were within five blocks of the waterworks building. Residents farther out bought water delivered on horse-drawn carts until the system was improved in the 1860s. Demand for other utilities prompted the erection of a gas plant, which began serving homes and businesses in 1856.

Traffic accidents occurred with some regularity when speeding wagons clashed or horses and mules grasped the upper hand from their drivers. Admitting nothing else of note was happening that day, the *Union* printed the following on November 19, 1855:

> *The fast nag that propels Langton's Express wagon gave us an exhibition of his powers of locomotion on Saturday afternoon, in a short, but animated run from the foot of K Street, along Front and up J Street to Third, with the wagon rattling and bouncing after him. At the latter point he was stopped by the vehicle coming in contact with the buggy of Dr. B.B. Brown, resulting in the loss of one wheel of the latter, but no injury to the former.*

The city stank from stagnant water in surrounding marshlands, human and animal waste and decaying rubbish. Heavy mists rising from tule swamps clouded winter landscapes. Rats, brought in by a host of vessels, jumped ship and multiplied—everywhere. Mosquitoes and other flying insects tormented humans and livestock. In the winter months, Sacramento's hotels and boardinghouses were crammed with prospectors forced by weather to leave their claims for the season. Merchants of all types realized fortunes from abundant, captive customers. Collectively, the displaced miners and new arrivals spent an average of between $1,000 to $3,000 a day at Sacramento's mercantiles, eateries, saloons, bowling alleys and gambling houses.

SACRAMENTO'S CITY CHARTER

The thousands of young gold rushers did not come with community building in mind; rather, most intended to extract a fortune from the ground and return home. However, some experienced lawyers and politicians who were, in the main, older than the average Argonaut had expressly come to bring California into the Union. They and other civic-minded Sacramentans held their first meeting at the St. Louis Exchange (a hotel) to select a town council.

Albert Mayer Winn, a Mississippi Militia veteran, was elected head of this council by his fellow delegates, becoming Sacramento's first de facto mayor. Winn formed a local chapter of the Fraternity of Odd Fellows to "visit the sick, relieve the distressed, and bury the dead." Winn Park at 2732 P Street honors his memory. Colonel James Zabriskie, a long-tenured judge from

New Jersey who was the personal friend of several U.S. senators, drafted the city's first charter. It was defeated by liquor and gaming interests that wanted no restrictions on their profits. Exasperated, Albert Winn posted a broadside in public places, excerpted as follows:

> On the first day of August, 1849, we were elected councilmen of this city, and our powers or duties were not defined. On the 13th of September following we presented to you a charter for your consideration, which you have seen fit to reject by a majority of 146 votes. Since then we have been unable to determine what the good people of this city desire us to do…if you have objections to particular features of the charter, then strike out [those] features and insert such as you desire. The health and safety of our city demand immediate action on your part, for…we can in fact be of no service to you without your confidence and consent.

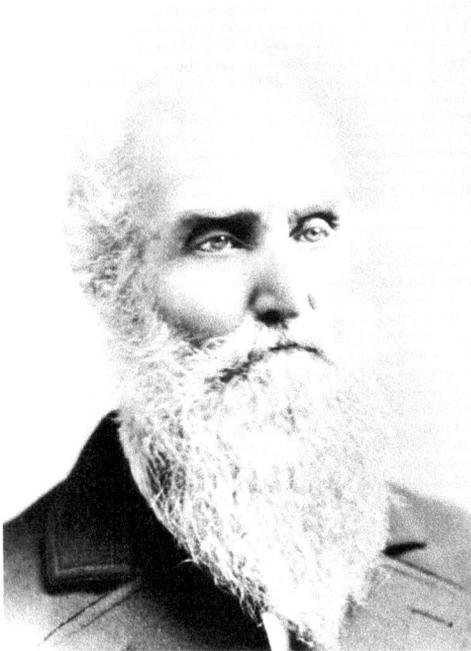

Colonel Zabriskie's charter, with a few modifications suggested by the voters, passed by 295 votes and became local law on October 13, 1849, making Sacramento the first chartered city in California. Sacramento was incorporated by the state legislature on March 18, 1850. At the April 1850 election, Hardin Bigelow from Michigan was chosen as the city's first elected mayor. Respectable citizens turned to churches as the center of their social and cultural lives and, for some faiths, a source of education for their children.

James C. Zabriskie composed Sacramento's first city charter. This undated portrait was taken at a San Francisco studio, after 1860. *Courtesy California History Room, California State Library, Sacramento.*

EARLY CHURCHES AND SCHOOLS

Before the gold discovery, no churches or schools dotted the Sacramento Valley landscape, primarily because American women and children pioneers entering California were relatively few. Thus, the hordes of predominantly male gold seekers were a continent away from the gentling influences of families and church attendance. Religious leaders arrived in late 1849 to salvage souls and forestall any further withdrawal from the Atlantic states' established church and family values. Most of the pre-1855 church buildings were destroyed in the 1852 or 1854 fires. They were rebuilt, sometimes at different locations. None still stands on its original site.

Sacramento's longest-lasting and most famous pioneer

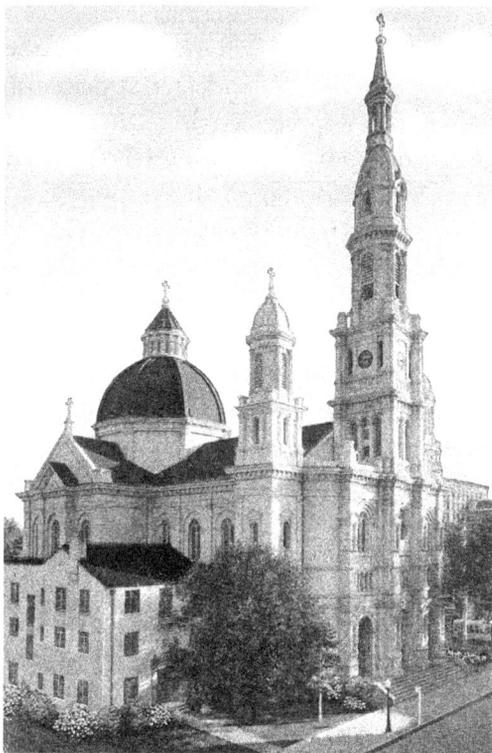

Cathedral of the Blessed Sacrament at K and Eleventh Streets. *Author's collection.*

religious leader was charismatic Reverend Joseph Augustine Benton, a Congregationalist pastor who held his first Sunday service beneath an oak tree on July 22, 1849. His deliberately nondenominational First Church of Christ (renamed the Presbyterian Church about 1850 and later the Congregational Church after the Presbyterians formed their own congregation in 1856), offered secular lectures and musical concerts on Sunday afternoons. His attempt to provide a school in a rickety shed in October 1849, with fewer than ten pupils enrolled, failed in less than two months due to inclement weather. The clergyman's initiative was rewarded that December. Benton, a Yale graduate before he studied theology, was named a founding trustee for what became the University of California.

He preached from his Sacramento pulpit on Sixth Street until March 1863, when he accepted a call from the Second Congregational Church in San Francisco. The Pioneer Memorial Congregational Church on L Street carries on Reverend Benton's spiritual legacy.

Sacramento's first church building, the Baltimore Chapel—so named because it was a prefabricated structure shipped around Cape Horn from Baltimore—was erected in 1849 by Methodist preacher Isaac Owens at Seventh and L. The only school noted in the 1851 city directory was taught at this location by Reverend James Rogers. Three years later, Jewish pioneers purchased the Baltimore Chapel, dedicating it as Sacramento's first synagogue and the first congregationally owned synagogue west of the Mississippi River just two months before the building was destroyed in the 1852 fire.

Reverend Osgood Wheeler supervised the organization of the First Baptist Church in September 1850, resurrecting lapsed efforts by others a year earlier. Reverend Wheeler opened his home as a private school for young ladies in 1854, a venture that closed when headmistress Mary Doty accepted a position at a Napa Valley girls' school the following year. Osgood Wheeler further contributed to the community when he later served as the corresponding secretary of the California State Agricultural Society.

Former gold miner Daniel Blue organized the African American Methodist Episcopal congregation in 1850, the first on the West Coast, from his home on I Street. The following year, St. Andrews AME Church (known then as Bethel African Methodist Episcopal Church) was erected on

First Baptist Church on Fourth Street, 1854. *Courtesy California History Room, California State Library, Sacramento.*

Seventh Street between F and G, replaced in 1867 with a brick building. The church housed a school for minority children, sponsored social events and hosted the California Colored Citizens' State Convention in 1855, 1856 and 1865. The first children to attend school classes there were the students of Elizabeth Thorne Scott Flood, an educated black woman born in New York who came to the gold fields with her first husband. Recently widowed when she arrived in Sacramento, she saw a need and filled it, opening her home as the first California school for black children on May 29, 1854. Fourteen black children enrolled. Soon, Mrs. Scott's classrooms were open to Native

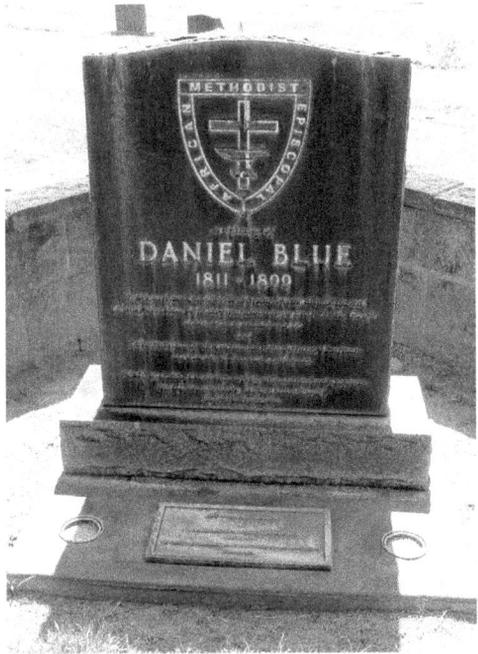

The memorial grave marker of AME Church founder Daniel Blue in East Lawn Cemetery. *Photo by author.*

American and Asian children as well. As the number of pupils increased, class location was changed to the more spacious basement of St. Andrews, where Elizabeth was an active member before her marriage to Isaac Flood and subsequent move to his Oakland residence.

The cornerstone of the Roman Catholic Church at Seventh and K Streets was laid on October 14, 1850, on land donated by California's first elected governor, Peter Burnett. Natural disasters felled successive building attempts until Archbishop Alemany officiated at ceremonies to construct a brick edifice on the site in 1854. The stunningly beautiful St. Rose of Lima Cathedral dominated the Sacramento cityscape until it was demolished in the late 1880s following completion of the Cathedral of the Blessed Sacrament at K and Eleventh Streets.

At the end of 1850, the Episcopal congregation, led by Reverend Orlando Harriman, was still holding services at the courthouse. Grace Episcopal Church on Eighth Street opened in 1856. The congregation reorganized as St. Paul's Episcopal Church in the 1880s and laid the cornerstone of

its present building on J Street in 1903. Southern Baptist missionary Reverend J.L. Shuck, attempting (with little success) to convert the Chinese to Christianity, presided over the Chinese Chapel on Sixth Street from 1855 to about 1861. Through the early twentieth century, German Methodists, Lutherans and Catholics, as well as Portuguese and Italian Catholics, all wishing to worship and enjoy cultural events in their own languages, formed new congregations and built new churches.

There were no tax-funded public schools in Sacramento until 1854. Private academies first appeared in 1850 and continued to educate with changing ownership and faculties for many years. The longest-lasting private school was St. Joseph's Academy, established in 1860 by the Sisters of Mercy.

An amendment to the city charter in 1853 levied a tax of one-fourth of 1 percent on all property, real and personal, to support free common schools. "Heretofore it has been deemed inexpedient to increase the burden of taxation...," the *Union* editorialized on April 11, 1854, "[but] the great expense of private school puts it out of the power of many parents to avail themselves of their benefits, while very many gentlemen are deterred from bringing their families to this city, for this defect alone."

The first public school opened on February 20, 1854, and the following year the *Union* reported the successful operation of six primary schools with aggregate enrollment of 320 pupils, male and female. The first high school opened in May 1855, with eighteen girls and twenty-one boys in attendance.

Those first classrooms were in rented or donated facilities. The first common school building was raised in fifteen days on the corner of Tenth and H Streets in January 1855, at a cost of $1,487. Costs, and enrollment, escalated as new grammar and high schools appeared. By 1890, the total valuation of city school property was $252,000, housing 2,293 primary, 1,103 grammar and 175 high school students. Sacramento schools were segregated until the 1870s. In 1894, Sarah Mildred Jones became the first African American woman in Sacramento to become principal of fully integrated Fremont Primary School at Twenty-fourth and N Streets.

While Sacramento's cultural and educational amenities were improving, its prime location had already made it a major freight and transportation hub via river navigation and inland transportation entrepreneurs.

THE FIRST STAGING IMPRESARIO

Twenty-one-year-old James E. Birch, an experienced stage driver in Rhode Island and perhaps a born entrepreneur, was among the thousands who came overland in 1849 to seek his fortune in California's mother lode. In love with beauteous Julia Chase, he had promised his sweetheart a mansion in Massachusetts from the fortune he expected to extract from the ground. His gold-mining endeavors proved disappointing, but he was ambitious, and he had no intention of going home empty-handed. He and his longtime friend Frank Stevens took up residence in bustling Sacramento City, where Jim saw that hundreds of gold miners were coming and going on foot and

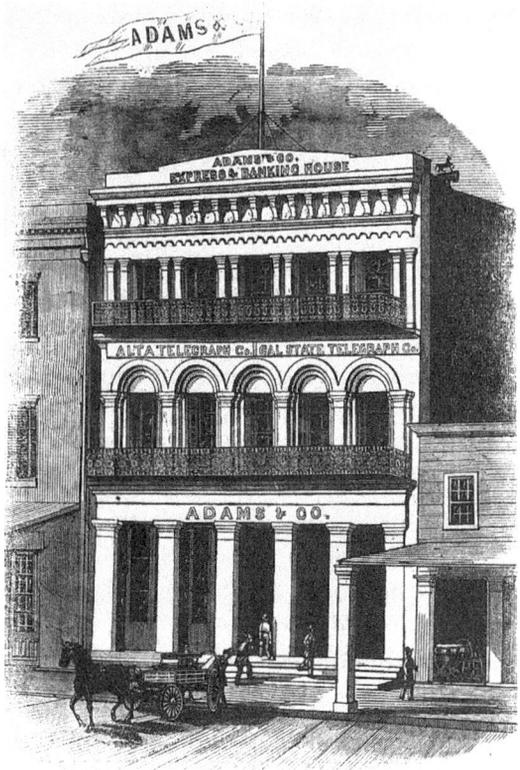

The Adams & Company Building, where James Birch's California Stage Company maintained executive offices. *Courtesy Library of Congress HABS CAL, 34-SAC, 17—1.*

figured thirty dollars per passenger was a reasonable price for transportation to the rich gold fields at Mormon Island thirty miles upriver. One day in September 1849, he appeared at the Sacramento River levee with a team hitched to a borrowed wagon, shouting, "All aboard!" Five years later, his greatly expanded stage lines left daily from Sacramento's Orleans Hotel on Second Street, and Jim Birch was the wealthy impresario of an empire on wheels named the California Stage Company.

He and Julia built their mansion in Swansea, Massachusetts, and had a son. Birch was aboard the palatial side-wheeler *Central America* in 1857 when

a storm damaged the ship some four hundred miles south of Cape Hatteras. More than $2 million in gold disappeared into the frothy black seas; hundreds of men perished, including Jim Birch. Earlier, Jim's success had convinced Frank Stevens, also an experienced reinsman, to establish his own line: the Pioneer Stage Company. In 1865, Pioneer bought the California Stage Company and shortly thereafter sold the combined businesses to Wells Fargo & Company.

Sacramento Celebrates Statehood

In the early morning hours of October 19, 1850, citizens were awakened by the steamer *New World*'s rapidly booming cannons, bringing news that California had been admitted as the thirty-first state on September 9, 1850. A horse rider dashed up and down the streets shouting the news. Citizens leapt from their beds to assemble on the streets, where they cheered, lit bonfires and exploded fireballs and powder crackers into the air. Brilliant candles and lanterns blazed top-to-bottom from the Crescent City Hotel, and the crack of guns and pistols added to the joyous din. Speeches dominated the Saturday evening ceremonies, eloquently delivered by judges, city aldermen and then–lieutenant governor John McDougal. Auctioneer R.N. Berry opened baskets of champagne. "The whole town were in excitement [*sic*]," the *Sacramento Transcript* enthused. "Everyone felt that it was a time for rejoicing and jubilee."

Part III
Troubles, Tribulations and Triumphs

CHOLERA

Excitement of another kind eclipsed the statehood celebration a day later when an unidentified immigrant was found on the levee, dying of cholera. Four days afterward, the *Sacramento Transcript* published a short list of cholera deaths, reporting the city's efforts to forestall an epidemic by burning immense quantities of street rubbish. It didn't help—the lists of victims grew longer. The cause of this dreaded scourge, which usually resulted in death within thirty-six hours, was unknown, as was its means of swift transmission to caregivers who touched the bodies or clothing of sufferers. Nineteenth-century medicine was ignorant of the benefits of sterilization; those who comforted the sufferer with alcohol rubs unknowingly sterilized their own hands, while those who ministered to the sick without this protection just as unknowingly endangered themselves.

As the number of victims increased, an estimated three-fourths of the population fled Sacramento in panic. A Sacramento correspondent to the *San Francisco Alta California* wrote on November 4, 1850, "The streets are deserted, and frequented only by the hearse. Nearly all business is at a standstill...there is an expression of anxiety in every eye...Deaths during the past week, so far as known, 188."

Until the epidemic abated around the middle of November, people were dying too fast to count despite heroic efforts by members of the Masons

and Odd Fellows. Anywhere from six to eight hundred met early graves, including seventeen devoted doctors. A second cholera outbreak in 1852 killed dozens more.

FLOODS

There were signs of previous inundations for those who cared to look—bits of driftwood stuck here and there in tree branches and the condition of the underbrush around the rivers—but no one looked too closely. The site at Sutter's embarcadero on the Sacramento River seemed too economically sound, and the winter previous to laying out the city had been mild. No one paid much attention to the fact that the land was very low. Despite their awareness of December's heavy, ground-saturating rainfall, Sacramentans were stunned on the morning of January 8, 1850, when rising floodwaters washed them from their beds. Within two days, the whole city up to a mile east of Front Street was under water. Tents collapsed, and untethered merchandise floated past flimsy frame buildings as small boats rushed to rescue the stranded. There was no sure escape; many drowned, and property losses were severe. Livestock, both dead and still living, swept by in the swollen torrent. Quite incongruously, however, the prevailing mood was one of great hilarity, especially among men in boats who consumed the free-for-the-taking liquor bobbing around them.

With only lukewarm support at the outset, businessman Hardin Bigelow instigated and supervised a project to build higher levees, an action that saved the city from another inundation later that year. Consequently, he became so popular that he was elected mayor in April 1850. Unfortunately, those first levee improvements proved inadequate. Sacramentans repaired and extended the city's levees time and time again.

Another flood wrought havoc in 1853. A flourishing village dubbed "Hoboken" sprang up on high ground near today's Sacramento State University campus. When the floodwaters drained away four months later, Hoboken disappeared, too. In every flood, distraught people, livestock and barking dogs crowded into the upper floors of hotels and office buildings. Those who heeded early warning signs made haste for the only hill in Sacramento, a remnant of eons of erosion. Formally known as Oak Ridge, or just "the ridge," the area was bounded by Nineteenth, Twenty-fourth, R and W Streets. Despite its later lavish mansions, it

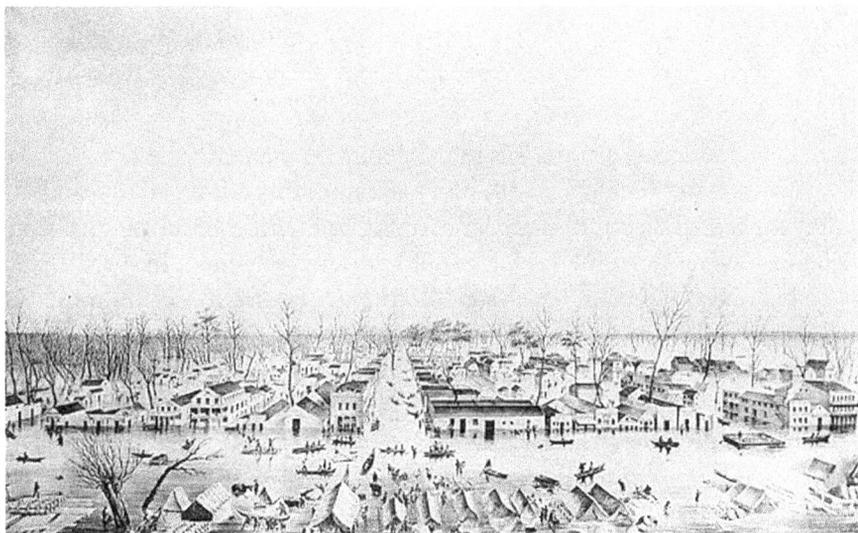

Sacramento's business district in January 1850, under water. *Courtesy Library of Congress HABS CAL, 34-SAC, 1—1.*

became comically known as Poverty Ridge because of the disheveled, disordered tents that appeared each time inundations dispossessed the flatlanders who took refuge there.

The largest flood disaster occurred in two parts. Lulled into a false sense of security by strengthened levees and almost nine years of mild winters, Sacramentans were unprepared for nature's onslaught in the winter of 1861–62. Deluged by a rainfall of 8.65 inches, the American River levee failed east of Thirty-first Street about mid-morning on December 9, 1861. Incessant storms brought another 15.04 inches of rain, and on January 10, 1862, a wall of water rolled steadily across town, ultimately flooding J and K Streets to a depth of four to five feet. Citizens took refuge on the second floors of downtown hotels and office buildings, on Poverty Ridge and on the high ground at the Sacramento City Cemetery. Four hundred families were left homeless, and five thousand people required aid during the three months the city remained under water. The only avenue of escape was by boat to the coast, as the Sacramento and San Joaquin Valleys were transformed into a vast inland sea three hundred miles long.

Hoping to prevent a future catastrophe, in 1864 the city rechanneled and straightened the last two miles of the American River to join the Sacramento River about a mile upstream of its old location. The last major inundation of the era occurred in February 1878, when the levees held with a foot to spare, but flooding continued to be a major problem into the next century.

FIRES

Like other California settlements in the 1850s, Sacramento was a tinderbox filled with wooden buildings, cloth-covered frame fabrications, tallow candles, gunny-sacked grains and camphene lamps (a mixture of turpentine and alcohol). Several "small" fires broke out but were contained. In April 1850, eight buildings on Front Street were consumed by fire in twenty minutes; merchants opened for business as usual the following Monday. Another fire that November destroyed four hotels. The first major conflagration—the Great Fire of 1852—erupted on election night, November 2. On November 4, the *Sacramento Daily Union* reported, "SACRAMENTO IN RUINS—That terrible destroyer which has heretofore laid in ashes every other important town in this state has at last visited [us] and in a few brief hours swept almost every vestige of it from existence."

Fueled by gale winds, the crackling inferno—allegedly visible from one hundred miles away—reduced nearly 90 percent of the city to ashes, including a few new brick buildings supposedly impervious to flame. Several churches, hotels, warehouses, groceries, dry goods stores, livery stables, restaurants, valuable merchandise, a hospital and hundreds of dwellings were devoured. Here and there a charred oak tree remained standing

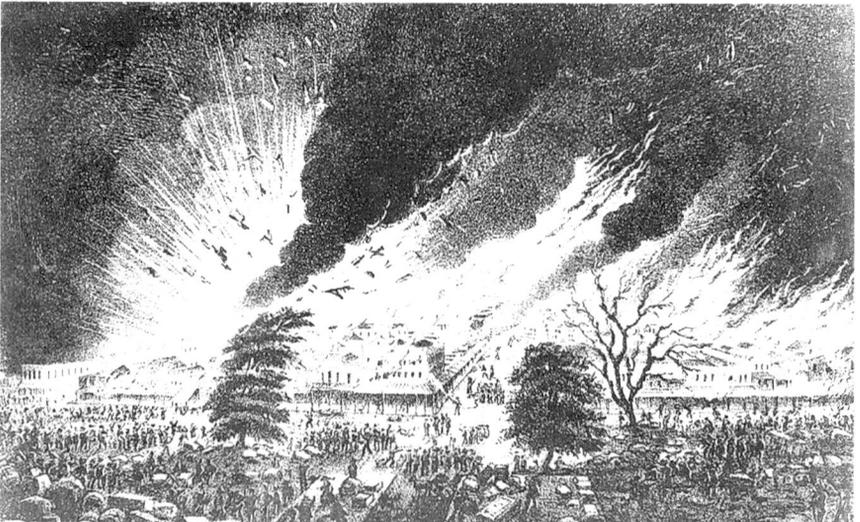

A drawing of Sacramento's Great Fire of 1852. *Courtesy Library of Congress HABS CAL, 34-SAC, 2—1.*

above the smoldering rubble. Miraculously, fewer than twelve persons were reported dead, and a few establishments escaped total destruction, but thousands were left homeless. Within a month, 761 structures were rebuilt, many of them in brick, and many installed with iron shutters to help retard fire-wind fanning.

In 1854, a camphene lamp toppled and shattered in a small frame building behind a furniture warehouse. The flames quickly leapt to the rear kitchen of the Sacramento Hotel on K Street, simultaneously igniting frame buildings on the same block. This time, the prevailing breeze of a sweltering afternoon on July 13 was minimal, and there was water from strategically placed cisterns, but the fire forced its way to Fifth and I Streets before it was contained, burning the better portion of twelve city blocks. The courthouse, the Congregational Church, four brick buildings, two hotels, two hundred frame homes and businesses and a fire station on Fifth Street were destroyed. No lives were lost; the *Daily Union* estimated damages at $350,000. Once again, Sacramento rebuilt.

Volunteer companies like Hook and Ladder Company No. 1, which organized before the 1850 fire on Front Street, fought these blazes. Sacramento's first tax-funded, professional fire department was created by the state legislature in 1872.

FRONTIER LAW AND ORDER

The first two years of the gold rush, though chaotic, were relatively innocent times until, inevitably, sophisticated swindlers, brawlers and murderous villains appeared on the scene and Sacramentans swung their share of miscreants from the end of a rope.

The first was twenty-year-old professional gambler Frederick J. Roe in 1850, arrested for murdering a bystander who tried to separate Roe from another man he was quarrelling with. An excited mob granted Roe a trial but voted against letting him have a lawyer, insisting that "simple facts did not require legal gloss." The predictable verdict resulted in a hanging that very day, although Roe's victim, who had been shot through the head, wasn't dead at the time Roe was executed.

In July 1851, three men were convicted of assault and robbery; all were hanged from a sycamore tree at Sixth and O Streets. Two years after that,

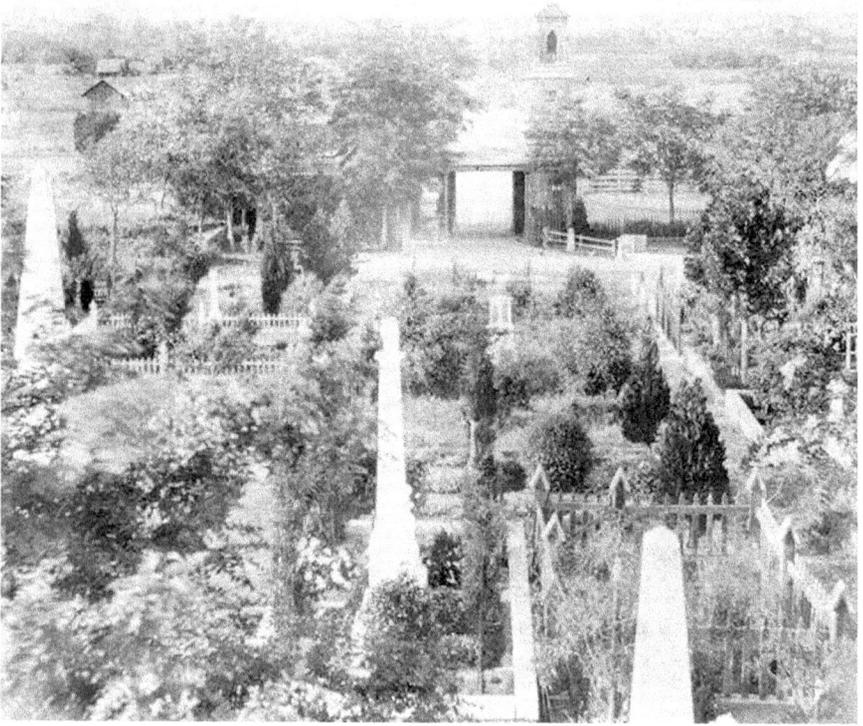

City Cemetery on Broadway, circa 1866. *Courtesy Library of Congress LOT 3544-31, no. 1079.*

a thief named John Carroll, alias "Bootjack," was murdered by members of his own gang. Carroll's former associates met their ends on a gallows erected on an open plain three or four hundred paces east of Sutter's Fort. In May 1856, China native Ah Chung was executed for the murder of Ah Lei. Chung claimed that the victim was his own unfaithful wife.

And so it went. The alleged seduction of a daughter, enmity between a worker and his employer, a disagreement over horse ownership, robberies turned fatal, slanderous printed articles, poor judgment caused by too much whiskey and "misunderstandings" all contributed to twenty-four executions of criminals in Sacramento between 1850 and the turn of the twentieth century.

Early on, Sacramento men formed a vigilance committee. However, the Sacramento group, never as well-organized, influential or effective as its San Francisco brethren, dispersed without making any banner headlines.

Cemeteries

There were two public secular cemeteries in which to bury convicted criminals, likely in separate sections away from the town's more respectable departed: City Cemetery and New Helvetia. The older was Captain John Sutter's original burial grounds northeast of his fort, donated by him to the city soon after its founding. Renamed New Helvetia Cemetery in 1850, it was purchased in 1857 by J.W. Reeves, a professional undertaker, with title reverting to the city following Reeves's death not long after the purchase. His widow continued to operate it for twenty-five years, but by 1912 the grounds were closed to new burials and showed "great neglect." Four years later, when the site was converted to a park, the remains of one thousand Chinese were removed and returned to their native land. In the 1950s, the city council offered this former graveyard property at Alhambra Boulevard and J Street to the school district for the construction of Sutter Junior High School (now Sutter Middle School). Between 1955 and 1956, the 5,235 remaining bodies were exhumed and reinterred in Sacramento City Cemetery or at East Lawn Memorial Park on Folsom Boulevard, established in 1904 on forty acres of farmland in what was then the outskirts of town.

The newest burial ground, established in December 1849, was ten acres on a sandy knoll south of the new city grid, another gift from John Sutter and co-owner Henry Schoolcraft, for this specific need. The City Cemetery graves were simple, often identified with carved wooden markers. Between then and the turn of the century, the Sacramento City Cemetery's acreage at Tenth and Broadway quadrupled, but care and maintenance steadily diminished until concerned citizens organized the Old City Cemetery Committee (OCCC) in 1986 to address its deteriorating condition. The OCCC is now an independent nonprofit organization, sponsoring fundraising programs that include annual Halloween lantern tours. (Visit oldcitycemetery.com/Lantern for more information.) By city ordinance in 2002, the official name is Historic City Cemetery of the City of Sacramento.

The Squatter Riots

Trouble began brewing as early as 1849, when a number of gold rushers wanted to acquire real estate in a town centered between the far-flung gold

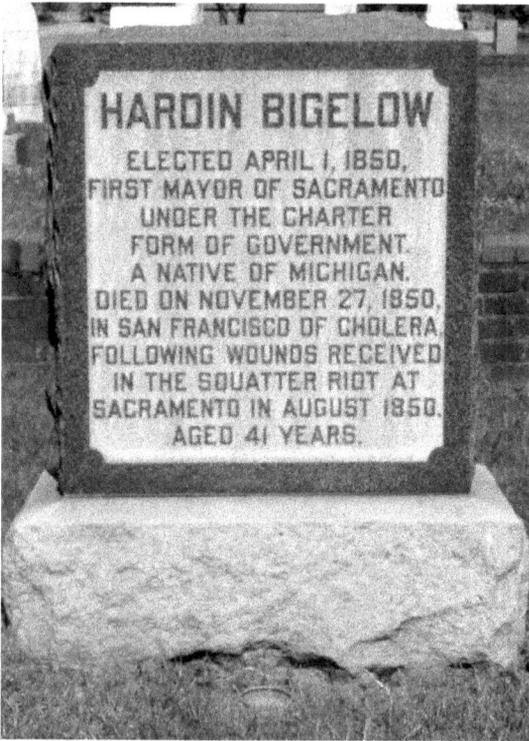

First Sacramento mayor Hardin Bigelow's memorial in Sacramento City Cemetery. *Photo by author.*

fields and booming San Francisco, in a territory ceded to the United States by Mexico but not yet admitted to the Union. As for Spanish or Mexican land grants, most Americans couldn't fathom how so few individuals in California could hold so many vast acres. It just wasn't right.

They didn't have to look far to find a surveying error in the map Sutter used to document his New Helvetia grant. Although clearly showing the intended scope of the southern boundary to a point well below today's Broadway, this boundary was labeled with a latitude that was actually several miles north. Thus, the newcomers claimed Sacramento lots were in the public domain and available for homesteading, despite the fact that the lots had already been paid for by others. Led by Dr. Charles Robinson from Massachusetts, they formed an association on December 7, 1849, calling themselves "settlers" and the lot owners "speculators." The titleholders called themselves "landholders" and their foes "squatters."

A series of hostile, destructive actions by both factions finally culminated in real bloodshed on August 14, 1850, in a shootout on Fourth Street between J and K. Mayor Hardin Bigelow was seriously wounded, and unarmed city assessor James M. Woodland was killed. Three squatters died in the fight. The remaining squatters fled to a roadhouse five miles east, in a settlement called Brighton. The next day, young Sheriff Joseph McKinney, who had been elected only four months earlier, was shot and killed outside the door of the roadhouse while trying to make an arrest. A number of squatters were killed or wounded in this fray. Armed citizens patrolled Sacramento

streets, acting mayor Albert Winn declared the city under martial law and Lieutenant Governor John McDougal left for Benecia to obtain military assistance. On August 16, 150 armed men arrived, but the violence was already over. That day, a large procession accompanied Sheriff McKinney's funeral cortege; Assessor Woodland had been buried the day before. Mayor Bigelow recovered from his wounds but died of cholera three months later. Dr. Charles Robinson, considered the ringleader and primary agitator behind the riots, later became the first governor of Kansas.

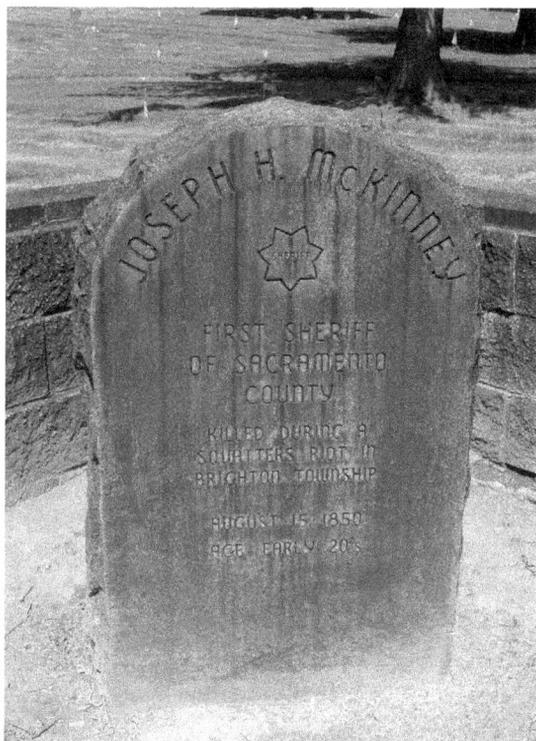

East Lawn Cemetery memorial to Sacramento County's first sheriff, Joseph McKinney, killed in the 1850s' Squatter Riots. *Photo by author.*

STEAMBOAT EXPLOSIONS

Before the California gold discovery, sailing ships were the mode of transport in oceanic waters. However, steamboats were the fastest transport for men in a hurry to get to the gold fields, and these vessels quickly grew in size and number. Horace Culver, the compiler and publisher of Sacramento's first city directory in 1851, notes in his *Historical Sketch*:

> *The first craft that came up the* [Sacramento] *river propelled by steam, was a small flat-bottomed affair built at Benecia…usually called the*

Washington. *As she came up, rippling the bosom of the placid waters as they slept in their beauty, she was hailed with cheers at every place where there was a tent or shanty; and having sent back a response, on she went puffing and wheezing with all her might at her little high-pressure engine.*

The *Washington* made its first appearance in July 1849. Other steam-powered craft soon plied the rivers, and in October the magnificent side-wheeler steamship *Senator* made its maiden voyage upriver. As vessels and steam engines got bigger, speed became an imperative—but steam-fueled watercraft presented inherent dangers. Turning a blind eye toward potential catastrophes, greed for higher profits spurred keen competition among the steamships' owners, and foolhardy ship captains engaged in races with passing vessels. Mishaps and minor collisions occurred so often that newspapers stopped reporting all of them.

One such irresponsible contest rocked Sacramento on Sunday, January 27, 1855, when the *Pearl* exploded on a return from Marysville. Its captain had bet cigars with his crew that he could outrun the *Enterprise* coming alongside them on the Sacramento River. The flaming explosion of the *Pearl*'s over-wrought boiler reverberated thirteen blocks distant from the mouth of the American River, where the disaster occurred. Masses of citizens descended on the levee to watch would-be rescuers bring corpses to the surface with hooks. Boatmen trolled the river for days, finally recovering seventy bodies that were then laid out in the City Hall and Waterworks building in hopes that they would be recognized. Few were claimed, although the remains of the *Pearl*'s captain and members of his crew were identified. City officials ordered a public funeral on January 29 for the upward of twenty-nine victims already recovered. Three thousand people, including seven hundred Chinese mourning their eighteen dead, attended the solemn ceremony.

The Middle Fork of the Sacramento River, which winds through several islands in the Sacramento Delta, was dubbed "Steamboat Slough" as the gold rush brought thousands into the region. Ship captains chose it over the "old river" route because it was more than eight miles shorter and several hours less by steamship. However, due to the silt buildup from hydraulic mining, by the late 1850s the slough was less traveled by the larger steamboats while remaining the preferred watercourse for flat-bottomed boats that stopped at the various landings. Riverboat mishaps and shipwrecks occurred here from time to time. In 1850, local newspapers reported that an unnamed vessel carrying gold bars

The Sacramento River near Steamboat Slough. *Photo by author.*

got stuck on a sand bar, where it blew up and burned. In October 1854, the schooner *Bianca* lost eighty to one hundred tons of cargo near Cache Creek, and in 1862 the paddle-wheeler *Nevada* sank at the mouth of Steamboat Slough while engaged in a race with the steamship *New World* from Rio Vista to Sacramento.

SACRAMENTO VALLEY RAILROAD (SVRR)

Joyously hailed as the first railroad west of the Mississippi, the Sacramento Valley Railroad officially opened with great ceremony on February 22, 1856. Tickets to the festivities cost ten dollars, to include a cold buffet, champagne and a twenty-two-mile ride with admittance to a Grand Ball at Meredith's Hotel in Folsom. None of the revelers seemed to care that the line ended there, instead of continuing on to Marysville as originally planned, or that a burst tube in the locomotive Nevada delayed a scheduled three o'clock departure from Sacramento. Everyone was too happy just to have this

"evidence of civilization and progress in the shape of the iron horse" after so many difficulties had delayed its completion.

By a chance stroke of fate, the line's founder, Colonel Charles Lincoln Wilson, who lost all he owned in a bank failure before the first rail was laid, had recruited New Yorker Theodore Dehone Judah as the SVRR's chief engineer. Judah was an acknowledged engineering genius who had accomplished the "impossible" task of constructing the Niagara Gorge Railroad when he was only twenty-one. Judah was twenty-eight when he arrived in Sacramento in May 1854, accompanied by his wife, Anna, his mother and other family members, reportedly already dreaming of the coast-to-coast railroad in which he would play a large part years later. The *Sacramento City Directory for the Year 1854–55* lists him at his business address, on the second floor of the B.F. Hastings Building. The Judahs resided in Sacramento for nine years while he traveled frequently to Washington, D.C., to lobby Congress for a transcontinental railroad. When his active work on the SVRR ended, he was employed as an independent surveyor and engineer on a number of other drawing-board railroads.

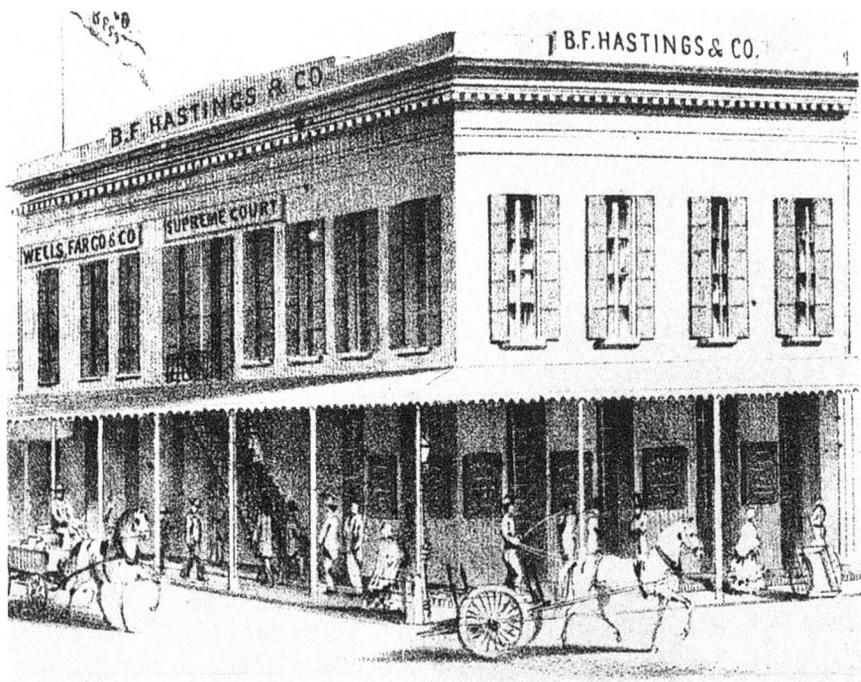

B.F. Hastings Building on J Street, circa 1857. *Courtesy Library of Congress HABS CAL, 34-SAC, 18—1.*

Before, during and after construction of the SVRR, promoters proposed and incorporated competing railroad lines to enter or leave Sacramento to and from various points, but none of these materialized with Sacramento as a terminus until the mid-1860s. Meanwhile, the Sacramento Valley Railroad acted as a funnel in both directions for the traffic traveling between Placerville and San Francisco by way of river steamers and stage companies. The first locomotive imported from the East was the Elephant in 1851, intended for use in moving the sand dunes on the San Francisco peninsula. The plan didn't work out, and four years later the SVRR purchased it. Track materials arrived that same year, as well as the locomotive Sacramento, the first to operate in California.

Finally, seven months and $1,380,000 after the first rail was laid on August 9, 1855, the Sacramento Valley Railroad began serving passenger and freight customers. Financially successful from the outset, its net earnings of $53,300 the first year of operation steadily climbed to nearly double that at the end of five years. The railroad's success, however, alienated the Sacramento business community. Teamsters were angry because the railroad acquired much of their freight business. Merchants were unhappy because passengers didn't stop in the city as long as they had previously and therefore spent less money.

The road's operating philosophy finally incurred the wrath of the general public when the 1861–62 flood washed through the valley. For several blocks, a railroad embankment ran parallel to the R Street levee as the trains entered the city, and an ordinance specified that the SVRR build a bridge over a slough to let excess water pass. For unknown reasons, the railroad company created a solid embankment filling in this bridge. On the morning of December 9, 1861, the start of the catastrophic inundation, mountain runoff from three days of rain created an immense flow of water that breached an eastern section of the collar-shaped levee and, with nowhere to go between the R Street levee and the filled-in railroad bridge, backed up into the city proper. Soon, the water level was ten feet higher *inside* the levee than outside. A chain gang blasted out a section of levee at Fifth and R, but the released torrent of water that poured into the Sacramento River below the city swept six homes right through the opening. With some of its rails and ties between Front Street and Brighton Station ripped up by the water, the SVRR's revenues plummeted the following year.

The Central Pacific Railroad Company purchased the SVRR in 1865. Today, the Light Rail commuter train uses the same track bed, but not the

same tracks, in its daily transit between Sacramento and Folsom. Historical Landmark No. 526, a plaque at 1800 Third Street, commemorates the location of the Sacramento Valley Railroad's original passenger terminal at Third and R.

THE PONY EXPRESS

Anyone awake in Sacramento at 2:00 a.m. on the dark, rain-drenched morning of April 4, 1860, might have heard the clatter of hooves galloping down J Street as a young, superb horseman named William (Sam) Hamilton sped east. He was the first Pony Express rider to depart from California on the two-thousand-mile route across often-barren country, just as his counterpart was doing from St. Joseph, Missouri. Sam carried sixty-nine tissue-thin letters, prepaid at five dollars per half ounce *plus* U.S. postage, in a specially made, waterproof leather holder called a mochila. Five hours and sixty miles later, he handed the mochila to Warren ("Boston") Upson at Sportsman's Hall, also known as the Twelve Mile House, who carried it through a blizzard over the Sierra in an ordeal that took on the aura of legend. Somewhere east of Salt Lake City, east- and westbound riders passed one another on Sunday, April 8. Sam Hamilton was waiting at Sportsman's Hall, twelve miles east of Placerville, when the first westbound mochila arrived there on April 13. Sixty miles downhill, outside the crumbled walls of John Sutter's old fort at Twenty-seventh and L Streets, nearly one hundred mounted men formed a double line along the road, intent on escorting Hamilton into Sacramento.

Downtown on dusty J Street, enthusiastic crowds jammed the sidewalks, balconies and rooftops. All manner of buntings and flags fluttered from public buildings; a crockery establishment had a hobby horse mounted before its awning posts, decorated with flags inscribed "Pony Express." At 5:30 p.m., someone on J Street spotted a cloud of rolling dust in the east. Almost simultaneously, a merry peal of bells rang out from church towers and firehouses. Cannons boomed as Hamilton's valiant roan mount thundered down the street toward a crowd wild with excitement. When interviewed, Sam Hamilton complained that the group who met him at the fort thoughtlessly spurred their fresh mounts ahead of him, creating a great dust that was annoying to him and possibly injurious to his horse.

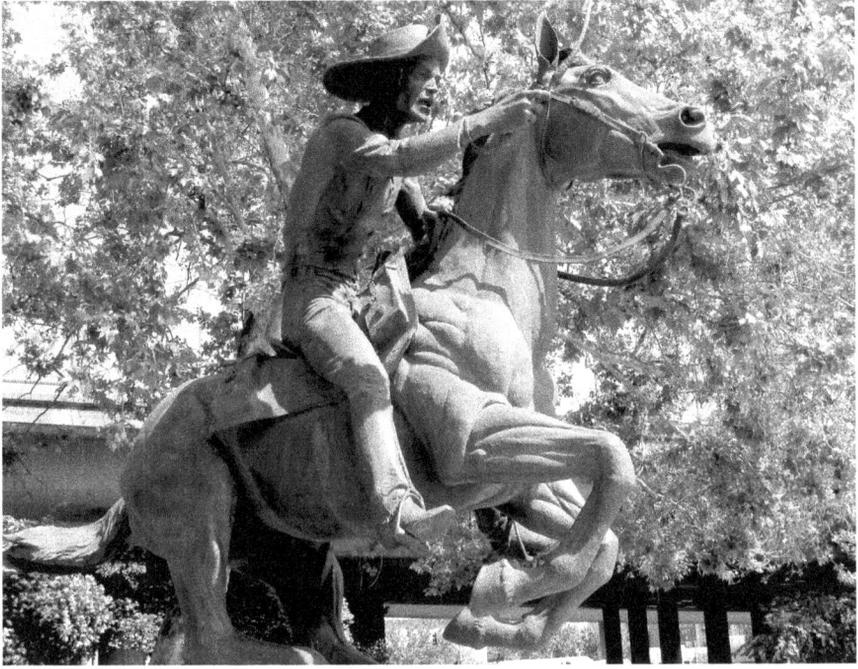

The Pony Express commemorative statue at Second and J Streets, Old Sacramento. *Photo by author.*

The romantic, dashing, awe-inspiring Pony Express, which cost its backers more in custom saddles, relay stations, salaries and expensive horseflesh than its revenues generated, lasted less than nineteen months. The death knell for the Pony was the loss of a federal mail contract combined with the 1861 completion of the transcontinental telegraph, linking the East via Omaha, through Salt Lake City and Virginia City to Sacramento and San Francisco. A statue on Second Street in Old Town Sacramento State Historic Park commemorates the tough, wiry Pony Express riders—legends in their own time—who together with their glorious steeds still excite the public imagination.

CONSEQUENCES OF THE MINES

Each year of the early 1850s saw more and more depletion of the placer gold (gold found near the surface in gravely sands and river bars). Yet gold,

and the quest for it, continued to impact Sacramento's economy and politics for decades because the notion persisted that the supply was inexhaustible: mining the precious ore just required more sophisticated methods. Many an independent miner, laboring dawn to dusk with hoes and shovels, then swirling sediment in pans, was happy to join organized river-mining projects of thirty or more men in building dams and flumes to divert watercourses, hoping to expose gold at the bottom of riverbeds. More often than not, these companies lost an entire summer's hard labor when the first rainstorm inevitably brought rising waters crashing through their feeble barriers.

Quartz mining, also known as hard-rock mining, began about 1851. Following and uncovering seams, or veins, of gold in solid rock meant extensive underground tunneling and costly quartz-crushing machinery. This method, financed by speculative investment, drew hundreds of disappointed placer miners and newcomers as paid wage earners. The diversion of natural watercourses and the annihilation of untold acres of virgin forests for lumber to construct flumes, trestles and mineshaft supports weren't given the least concern; governmental oversight was nonexistent. For the operations that required substantial capital outlays, shareholders in Sacramento, San Francisco and elsewhere cared only about the return on their investment. Through all methods of gold mining, Sacramento merchants rang up substantial sales for boots, tents, tools, hardware, blasting powder, mules and carts, groceries and fine cigars. Sacramento freighters hauled these goods to

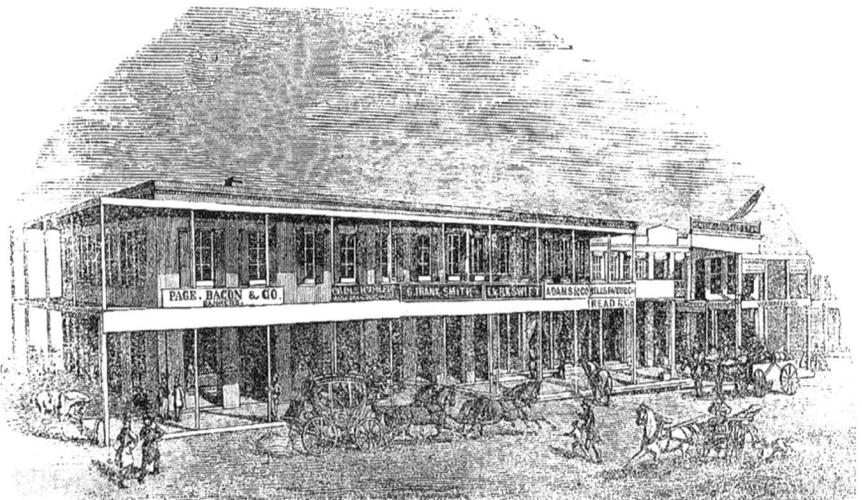

Page, Bacon & Company Building, circa 1850s. *Courtesy Library of Congress HABS CAL, 34-SAC, 7—1.*

the mines at high rates, and Sacramento-based express companies hauled the gold back to local bank safes.

Hydraulic mining, the technique of blasting away entire hillsides with jets of water fed through iron pipes and canvas hoses to hand-held, high-velocity nozzles, dumped tons of debris and significant quantities of mercury (used to trap finer particles of gold) into the watercourses. Before long, the riverbeds contained so much sediment that rain-swollen rivers had nowhere to go except over their banks, threatening the very survival of Sacramento during the 1861–62 floods that washed away homes, merchandise and cultivated acreage. The aftermath of each substantial inundation was mile upon mile of a deep, slime-oozing mud called "slickens" that buried crops and hardened into an untillable crust. The brown sludge threatened steamboat navigation as well, so choking the currents of the Sacramento River by the mid-1860s that steamships scraped bottom or got stuck on sand bars on their approach to the Sacramento docks.

Awareness dawned. But Sacramentans, like the inhabitants of other towns, were too entrenched in the gold business to dare to take the mining industry to task for another two decades. From the late 1890s, dredging—accomplished by an endless chain of buckets hauling up mud and gravel from river bottoms and depositing it in sluice boxes aboard a boat—further scoured the rivers. Environmental legislation in 1962 brought a halt to this practice on the American River between the communities of Carmichael and Folsom. According to historian Greg Velm's *True Gold*, the Sacramento area is the largest dredge field in California.

RAISING THE CITY

The disastrous 1861–62 flood finally convinced Sacramentans that something more had to be done than just constructing higher levees: it was necessary to raise the level of the city itself. Begun in earnest circa 1863 and completed sometime in 1873, streets, buildings and sidewalks were raised eight to fifteen feet, depending on location—but without a master plan. The project was an immense, often perilous undertaking, with much of the costs borne by merchants and residents for bulkheads, sidewalks and modifications to their own properties. A home could be elevated for about $500; the 1,900-ton St. George Hotel cost $7,500 to lift with 250 jack screws and dozens of men.

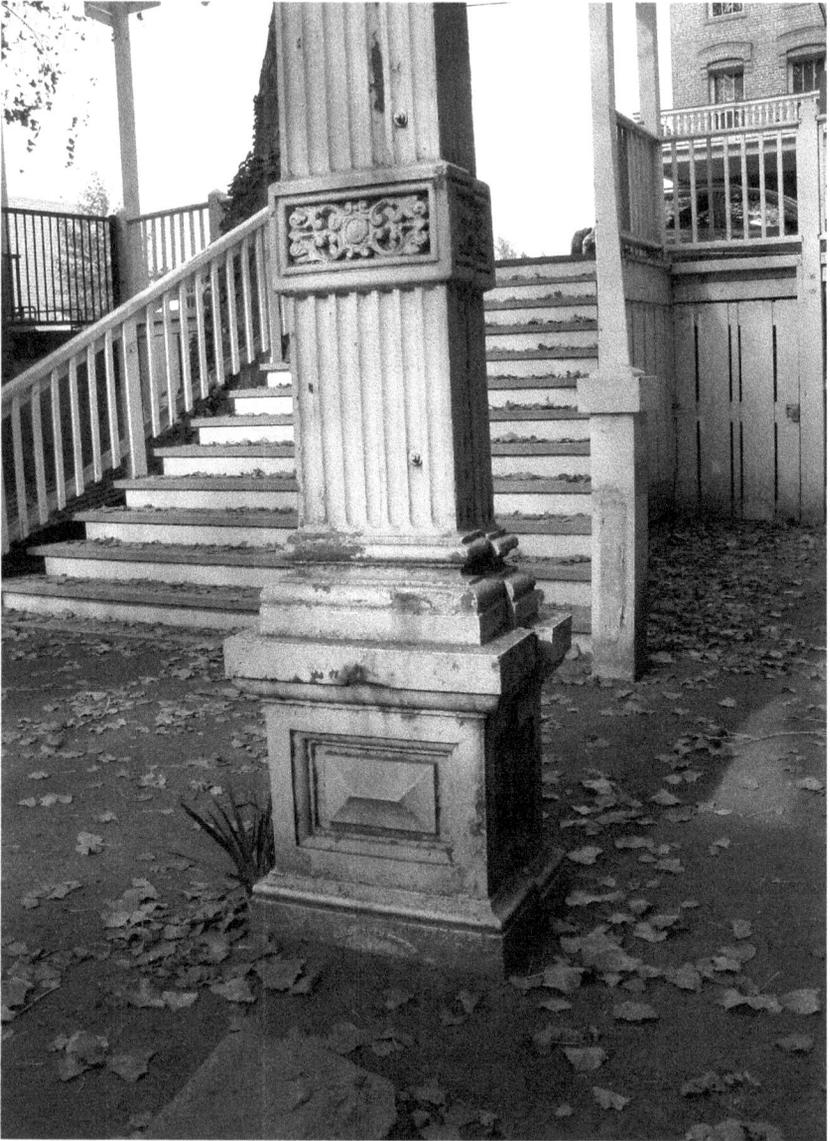

Pioneer Park in Old Sacramento displays cast-iron pillars, used as decorations at doors and windows, still standing at original street levels before the city was raised. *Photo by author.*

Tons of fill materials had to be left for months to settle. Incomplete sections were difficult to navigate by foot, horseback or wagon. Pedestrians risked their limbs on sidewalks that were sometimes raised before one store but remained at the old level at the next, necessitating crude ramps or stairways to get from

The first-floor entrance to this 1850s building remains at original street levels because alleyways weren't raised. *Photo by author.*

one level to another—inspiring some wags to declare that Sacramento was a city on stilts. Some individuals simply added floors, converting their original ground-floor entrances into basements. This herculean, fantastic feat in engineering and community effort—the only successful street-raising project

in California—won the admiration of many. The result is Sacramento's historic underground, a labyrinth of former street-level floors and dipping alleyways, exposed retaining walls, elegant brick archways and disappearing doors and windows. The Sacramento History Museum sponsors hour-long guided walking tours through these excavated areas that were above ground in the 1850s.

SERVING THE MINERS: BREWERIES AND WINERIES

Gold miners were a thirsty bunch, crowding into Sacramento saloons at each opportunity either coming from or going to the gold fields. Enterprising men with experience, or sometimes just imagination, saw an opportunity to profit.

Wineries appeared early. The first, established in 1851, was Jacob Knauth's Sutter Hall at Twenty-ninth and J. Knauth planted a twenty-acre vineyard east of Sacramento city and later a larger one across the river in Yolo County. His wine cellars were destroyed in the 1861–62 floods. Others, established in the 1870s and later, included Gerke Winery on Eleventh Street (gone by 1875), the California Winery at Twenty-first and R, the Pioneer Winery across the street, the Eagle Winery on Eighteenth Street, the Mazzini Winery on Third Street and the Roma Winery on Fifteenth, which produced eighty thousand gallons of wine and six thousand gallons of brandy annually at its peak. None of the city's pioneer wineries survived Prohibition.

Sacramento also fairly teemed with breweries. German immigrant Peter Cadel opened the Galena Brewery in 1849, in a small frame building one hundred yards east of Sutter's Fort, at the northeast corner of Twenty-eighth and M Street (Capitol Avenue). Cadel's brewery and his early day competitors, such as the short-lived Zins and Weiser Brewery on nearby city blocks, likely produced just six to eight barrels per brewing process. Cadel's brewery and its successor owners lasted into the early twentieth century; Zins and Weiser's business was destroyed by fire in 1851. Both breweries functioned on land now occupied by the sprawling Sutter General Hospital complex, private medical offices and surrounding commercial outlets.

Through the end of the century, new operations established ever-larger, higher-capacity facilities, among them the Phoenix, Sacramento,

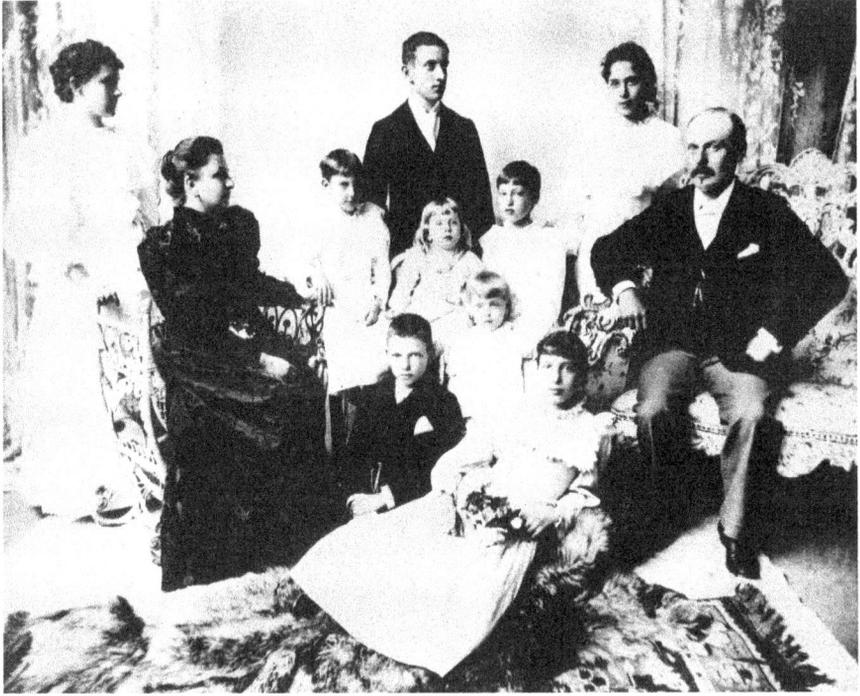

Buffalo Brewery owner Herman Grau and family, circa 1890s. *Courtesy Nancy Ware Family Collection.*

Sutterville, Pacific, Union, Ruhstaller and Capital Breweries. By far the largest and best capitalized—in fact, the largest brewery west of the Mississippi—was German-born Herman Grau's Buffalo Brewery, which opened to much fanfare on May 10, 1890. Its main building stood five stories high, attached to a four-story icehouse for cooling the beer, allowing Buffalo to brew year round despite Sacramento's sweltering summer weather. Constructed at Twenty-first and Q Streets, the plant covered almost an entire city block. Prohibition ended the Buffalo Brewery's glory days in 1919, although under the direction of company president Frank Ruhstaller Jr., the facilities were used to manufacture ice, "near beer" and malt extracts. In the 1950s, the massive plant was demolished and replaced with offices for the *Sacramento Bee.*

Early Politics

Land Commission of 1851

The aftermath of the Squatter Riots, combined with land speculation and a financial crisis in 1850, left Sacramento land titles in appalling disarray. Worse was to come.

The United States, having ratified the Treaty of Guadalupe Hidalgo that ended the Mexican-American War, chose to disregard those articles of the treaty that promised to honor the ownership of existing Mexican land grants with its own Land Claims Act of 1851. Supposedly a means of adjudicating claims, the act created a darker, more ominous cloud on Sacramento property titles than even the sloppy deed-filing practices during the 1849 heyday of land speculation. From the late eighteenth century, Spain and then Mexico had encouraged colonization of California by awarding tens of thousands of acres to private citizens. Under both regimes, the applicant submitted a hand-drawn map of the area desired. Surveys were thought unnecessary (although John Sutter had, in fact, commissioned one). Boundaries were indicated by geographic features: a river, a hill or mountain range, a lone oak tree in an expanse of wild oats. Now, documents relied on for decades were challenged and judged insufficient. Those who had purchased Sacramento lots from Sutter under the right of ownership granted to him by Mexican governor Juan Alvarado were stunned to discover that the Land Claims Act of 1851 jeopardized their holdings.

In an editorial published by the *Sacramento Daily Union* on June 12, 1860 (reprinted from the *Hesperian*), John S. Hittell wrote:

> *The Federal Government...delayed action through '48, '49, and '50; and first in '51 passed an Act nominally to "settle" private land claims* [but] *really to unsettle them* [and] *keep them unsettled. That Act provided for the organization of a Court or Land Commission to try these claims; declared every grant of land in California to be legally void, though it might be equitably good, and provided that every...claim should be lost to the owner unless he should sue the United States... the claimant was to be opposed—that is, persecuted—by a law agent appointed by the United States, with instructions to contest every claim to the utmost.*

The years-long process, which began with the Land Commission's tribunal of three judges, continued with an appeal to the District Courts (even if the claimant won in the first step) and next went to the United States Supreme Court, was all too often ruinously expensive. Sacramento

The Union Hotel on Second Street (restored) was a popular gathering place for politicians and lobbyists from 1855 to 1870. *Photo by author.*

lawyers who specialized in property rights were kept busy and well fed. More and more newcomers kept arriving, many of whom preferred to "occupy" lots and gain title under existing federal frontier homestead rules instead of purchasing. Influenced by this growing faction, the mayor and city council proposed to appropriate $5,000 to send a local lawyer east to contest "the claims of John A. Sutter to land within the corporate limits of [the] city." The proposal was denied by the Sixth District Court after a Sacramento citizen charged the mayor and city council with fraud and collusion in the transfer of funds for that purpose.

The Supreme Court finally confirmed Sutter's New Helvetia Grant in 1859, whereupon Sacramento real estate slowly recovered, subject to ordinary market conditions of location and supply and demand.

SLAVERY

Delegates to California's first Constitutional Convention in 1849 banned slavery in the state-to-be, less from altruistic motives (although some delegates were abolitionists) than from fear that slave labor in the gold fields would be economically detrimental to the thousands of independent gold miners already there. California was admitted to the Union as a free state in 1850, but that didn't stop heated, and divisive, proslavery agitation within its borders right up to the passage of the Thirteenth Amendment on January 31, 1865.

The state Whig Party held its 1851 convention in Sacramento with much pomp and celebration. The party was victorious in filling important Sacramento city and county positions and a state assembly seat yet never managed to elect a governor or senator. With its members torn in two directions over slavery, the Whig Party dissolved by the late 1850s. Six of California's first seven governors were Democrats, men with varying degrees of pro- or antislavery beliefs. Southern-raised Peter Burnett, California's first elected governor, opposed granting full citizenship rights to African Americans, as well as the immigration of free blacks into the state. By 1853, the Democratic Party had split into two warring factions over the issue. Proslavery "Chivalry" Democrats threatened to divide the state in half unless it accepted slavery, while Free-Soil Democrats led by former lieutenant governor David Broderick (who served in Governor John McDougal's one-

year term from 1851 to 1852 after Burnett resigned) hotly argued against the spread of slavery into new states and territories.

Into this breach stepped the Know-Nothings (officially, the American Party), who swept Sacramento attorney J. Neely Johnson into the governor's chair in the 1855 election. Nominally opposed to slavery, the Know-Nothings were far more vehemently opposed to increasing foreign immigration, non-citizens holding political office and Catholics, whom they suspected were politically influenced by the power of a foreign state—the Pope. Sacramentan Edwin Bryant Crocker, an attorney and adamant abolitionist who later served on the California Supreme Court, spearheaded the organization of the California Republican Party in 1856. In January 1862, California's first Republican governor, Sacramento merchant and soon-to-be railroad mogul Leland Stanford, was forced to travel to his inauguration by rowboat during the worst flood the city had suffered to date.

Until 1863, when the term limit was changed to four years, California governors served two-year terms. Pennsylvania native John Bigler, a self-educated lawyer who arrived in Sacramento in 1849 and who was widely applauded for his selfless aid to sufferers during the 1850 cholera epidemic, was the only nineteenth-century governor to be elected for two terms, 1852 to 1856. During his tenure, a jewel-like alpine lake in the high Sierra was named Lake Bigler in his honor. Bigler advocated restriction of Chinese immigration, a sentiment echoed in many quarters, but his administration was plagued with activities by proslavery extremists and charges of fiscal extravagance. By the early 1860s, public opinion held that Bigler had failed to distinguish himself, and Lake Bigler was renamed Lake Tahoe. However, he did effect one major change. On February 25, 1854, Governor Bigler signed into law a provision that made Sacramento, his adopted city, the permanent site of California's capital.

LOCATION OF THE CAPITAL

Prior to this, California's capital had shifted between San Jose (the legal capital established by the 1849 Constitutional Convention held at Monterey), Vallejo, Sacramento and Benecia, all deemed unsatisfactory by legislators for one reason or another. Yet Bigler's legislation didn't end the matter because renewed politicking almost immediately discredited the new chosen site.

The California State Capitol Building under construction, circa 1866. *Courtesy Library of Congress LOT 3544-33, no. 1208.*

San Jose took its cause to the California Supreme Court, which decided that since the act to change the capital hadn't been passed by a two-thirds vote in the legislature, it was unconstitutional—a decision later reversed. Sacramento's courthouse building at Seventh and I Streets hosted the legislature for the 1852 and 1854 sessions until the building was destroyed in the July 1854 fire. Determined to remain the capital city, Sacramento immediately constructed a larger, Ionic-style county courthouse replete with ten massive pillars, completed in January 1855, and used as the state capitol building from 1855 to 1869. In the meantime, considerable agitation by San Francisco and Oakland, each claiming Sacramento was unfit as the capital because of its vulnerability to flooding and simultaneously promoting themselves as more desirable locations, swirled about in legislative sessions and newspapers. An April 1856 law providing for construction of a capitol building on a midtown public square was postponed in 1858. Two years later, Sacramento authorities purchased property between L, M (Capitol Avenue), Tenth and Twelfth Streets, paying the landowners $65,617 for the parcels and levying a tax for the same on local residents. The Board of Supervisors deeded these blocks to the state in April 1860.

At last, ground was broken for excavating the foundation on September 24, 1860, and the following May the cornerstone was laid with imposing

Masonic ceremonies witnessed by a large crowd. However, the contractors quit on January 1, 1862, having suffered heavy losses in the December flood, a calamity that once more opened the subject of removal to another city, and legislators were forced to adjourn to San Francisco for the duration of the 1862 session. More dissent from San Jose followed, but work renewed in 1863, when the foundation walls were raised another six feet. Progress was slow, aggravated by shortages of funds and materials during the Civil War. Governor Haight and the secretary of state moved into the building in November 1869, with scaffolding still in place and the dome unfinished. The grounds were expanded to N and Twelfth Streets in 1872. Despite completion of the Capitol Building in 1874, political bickering continued, with proposed removals to San Jose in 1893 and 1903 and another to Berkeley in 1907.

Sacramento's handsome brick and granite Neoclassical-style Capitol has undergone a number of additions and remodels during its lifetime.

CONFLICTS AND INFAMY

Sacramento's earliest lawmakers were rumored to indulge freely in distilled spirits and strut about the legislative hallways with guns strapped beneath their coats. Certainly insults, innuendos and charges of corruption, malfeasance and incompetence swirled about elected officials, mudslinging that continues today. But in the gold rush era, politicians were not above using physical means to intimidate or silence their foes. In 1856, quick-tempered, self-important Judge David S. Terry, a sitting justice on the California Supreme Court, stabbed a member of the San Francisco Vigilance Committee with a Bowie knife. His victim survived. Judge Terry was a Sacramento resident during his tenure on the high bench from November 1855 through September 1859. He is shown in the 1860 Sacramento city directory (published in 1859) living with his first wife, who later died, in the Greek Revival–style house on F Street formerly occupied by Governor Johnson, still known as the J. Neely Johnson House.

Three years after the near riot–inciting stabbing episode, Judge Terry was a principal in arguably the second most famous duel in American history after the Aaron Burr–Alexander Hamilton "affair of honor" in 1804. Proslavery extremist Terry challenged antislavery U.S. senator David C. Broderick to a duel—illegal in California by then, but no one objected. Broderick was an

expert shot, but the pistols chosen for the event were faulty, a fact Terry allegedly knew before he faced his opponent on the dueling ground. After Broderick's weapon discharged into the ground, Terry took careful aim and fired, hitting Broderick in the left side of his chest. David Broderick, unscrupulous in life, died a martyr three days later. Ten days afterward, Terry was arrested and tried for murder but walked out of court a free man when his friend Judge Hardy dismissed the charges. When the Civil War erupted in 1861, Judge Terry went east to volunteer his services to the Confederacy. In the late

The J. Neely Johnson House on F Street. *Photo by author.*

1880s, the town of Broderick in West Sacramento was named in honor of the slain statesman.

EXPERIMENTS

Beset with lack of funds from inception, and paralyzed by state laws that limited its taxing ability, the city of Sacramento thought it could save duplication of efforts and expenditures by merging with Sacramento County to form an all-in-one city-county government in 1858. The grand plan vested government in a Board of Supervisors that was responsible for everything: taxes, police departments, fire prevention, water supplies, sidewalks, prohibiting houses of ill fame, preventing riots, licensing coaches for hire and myriad other miscellany. After two years, it was generally conceded that

extensive amendments to the Consolidation Bill were imperative, although few could agree on their content. The anticipated reduction in expenses hadn't materialized, administrative costs had increased and bureaucratic inefficiency was frustrating. By 1862, the public was demanding a divorce of the city from the county, and the Consolidation Act was repealed in 1863. Ballot measures to repeat this experiment were rejected by Sacramento voters in 1974 and again in 1990.

SACRAMENTO'S CIVIL WAR CONTRIBUTIONS

Because troop transport to the eastern warfront was prohibitively expensive, conscription was not extended into the Pacific Coast states. Still, thousands volunteered. The California Volunteers formed statewide to repel feared invasion by Confederate forces that wanted California gold to finance their war machine. Individuals from Sacramento's Sutter Rifles, Washington Rifles, City Guard, Turner Guard and the Sacramento Hussars traveled east to fight with Union forces or joined the California Volunteers. Sacramento's primary contribution was the money it raised for the Sanitary Fund, a precursor to the Red Cross. Organized fundraising activities included picnics, theatrical entertainments and church-sponsored bazaars. Prominent men formed the Union Club of Sacramento, modeled after eastern prototypes. Sacramento women accepted the burden for the collection of lint (threads) from old linen tablecloths and bedding, a time-consuming process of painstakingly picking apart cut squares of cloth thread by thread. These were processed into rolled bandages and sent to the front lines.

In the main, Sacramento citizens were pro-Union, celebrating the almost simultaneous Union victories at Gettysburg and Vicksburg with a triumphant torchlight procession through the city streets in July 1863. Some one thousand citizens, on foot or in carriages, followed fire engine companies, militia units and musical groups on a march that snaked along buildings festooned with American flags, culminating in fireworks in front of the preeminent Orleans Hotel. Confederacy advocates got no sympathy from the powerful *Sacramento Daily Union*. Near the war's end, the newspaper reported that Montgomery Corse, the former manager of the Orleans Hotel, had been captured by Union general Philip Sheridan: "[Corse]...returned to Virginia about 1857...We rejoice that his career as a rebel is thus ingloriously ended."

Part V
The Central Pacific Railroad

ORIGINS

Thanks to steam locomotive technology imported from England, eastern and southern America developed railroads beginning in the 1830s, over time pressing westward to accommodate a spreading population. There were none in California until Theodore Judah built the Sacramento Valley Railroad in 1855–56. Dreaming of bigger things than a short flatland rail line, Judah became obsessed with a vision for laying track eastward over the Sierra Nevada. Since most 1850s minds viewed crossing the towering peaks of the Sierra by rail as the equivalent of bicycling to the moon, he became known as "Crazy Judah."

Undeterred, Judah sailed coast-to-coast more than once to promote his project, pressing his pamphlet, *A Practical Plan for Building the Pacific Railroad,* into the hands of every congressman or potential private financier he could buttonhole. Indeed, Congress had been considering proposals for a transcontinental railroad for some time but, divided by competing sectionalist interests, couldn't agree on a route.

Judah persisted, swallowing one disappointment after another until December 1860. With the help of Sacramento jeweler James Bailey and *Sacramento Union* editor Lauren Upson, Judah presented his ideas to thirty Sacramento businessmen at the St. Charles Hotel on J Street. Intrigued, merchants Leland Stanford, Mark Hopkins, Collis Huntington and Charles

Crocker convinced themselves and the others to finance a complete survey of Judah's proposed route. A year later, Judah presented his formal report. Using donkeys for transportation as he surveyed several possible routes, and without the overview available to modern engineers, Judah settled on an unconventional approach no one else thought possible across a most difficult natural obstacle. His vision, genius and skills are still evident in the route along a natural ridge, the horseshoe-shaped gentle incline around Donner Lake and other engineering feats that permitted the limited-horsepower locomotives of that day to cross the formidable peaks and chasms at grades of less than 2 percent.

Six months after agreeing to undertake the project, the group had enough stock subscriptions to incorporate the Central Pacific Railroad (CPRR) Company of California; all but two of the original directors were Sacramento residents. When the long-dreaded Civil War erupted in April 1861, the withdrawal of southern congressmen meant no further opposition to the northern route the Union urgently needed for transportation. President Lincoln signed the Pacific Railroad Bill on July 1, 1862, enabling the creation of a Union Pacific Railroad Company to construct the eastern end of a transcontinental line, simultaneously assigning the more difficult western portion to the CPRR. In November 1862, Sacramento's Board of Supervisors granted the tract of land known as Sutter Lake (also known as Sutter's Slough or China Slough) with the right of way and use of streets, levee and river front to the Central Pacific Railroad Company.

Formal inauguration took place at the foot of K Street on January 8, 1863, a clear but cold and blustery day. According to the January 9 *Sacramento Daily Union*:

> *The skies smiled yesterday upon a ceremony of vast significance to Sacramento, California and the Union. With rites appropriate to the occasion, and in presence of the dignitaries of the State…and a great gathering of citizens, ground was formally broken at noon for the commencement of the Central Pacific Railroad—the California link of the continental chain that is to unite American communities now divided by thousands of miles of trackless wilderness…Among the assemblage were pioneers, who had assisted in laying the foundation of the Golden State, who had dreamed, toiled and schemed for years in behalf of this grand enterprise, and clung with steady faith…to the belief that they would live to witness the consummation of their hopes.*

Flags and banners attached to storefronts and draft horses rippled in the breeze. Spectators in the immediate vicinity of the podium found dry footing in bundles of hay strewn about, while others watched from balconies or the relative comfort of their wagons and carriages. Reverend Joseph Benton offered a prayer, Governor Leland Stanford shoveled symbolic earth on the embankment while the crowd cheered and the Sacramento Union Brass Band played "Wait for the Wagon." Speeches lasted long into the afternoon.

It was a lovely beginning. Actual construction was another matter, one that Theodore Judah did not live to see fulfilled. Sailing to New York after a falling out with his Sacramento partners, Judah contracted yellow fever and died on November 2, 1863, at age thirty-seven. An elementary school in the McKinley Park area is named in Judah's honor, and a monument to his accomplishments stands at Second and L Streets in Old Sacramento.

THE GOLDEN SPIKE

Over a period of six years, the CPRR dealt with spiraling costs, delays caused by weather and the need to build twenty-three miles of snow sheds to protect the track, financial difficulties caused by governmental haggling over subsidies and other issues, controversy and litigation against the company, the danger and uncertain outcome of blasting fifteen tunnels through solid granite (the longest was the 1,658-foot summit tunnel) and labor problems, specifically the resentment engendered by on-site construction boss Charles Crocker's hiring of Chinese laborers, who were derisively referred to as "Cholly's Pets." These industrious laborers conquered each peak and abyss with nothing more than picks, shovels, hand-operated drills and blasting powder. On May 10, 1869, a ceremonial golden spike joined the CPRR and Union Pacific Railroad tracks at Promontory, Utah. America's first transcontinental railroad was complete at last. Freight and passengers could now reach the East in ten days instead of weeks by sea or months in a covered wagon.

However, mishaps delayed the Golden Spike ceremony two days later than anticipated. Along with invited delegates from every northern California county and hundreds of celebrants from surrounding farming communities, ecstatic Sacramentans went ahead with their own planned lavish celebration on May 8. Cannon fire signaled the start of the official parade, followed by

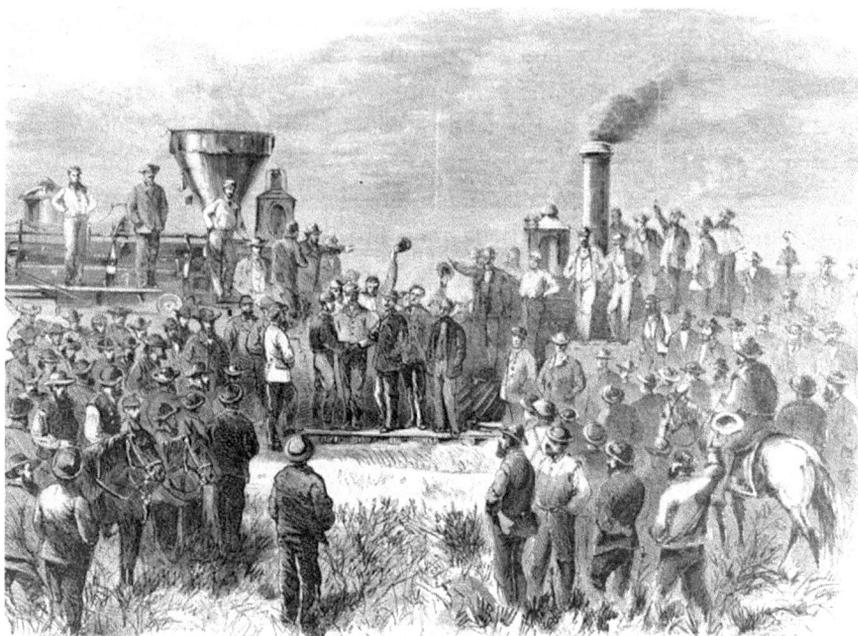

The Golden Spike Ceremony as illustrated in *Harper's Weekly* in June 1869. *Courtesy Library of Congress Illus. in AP2.H32 CASE Y[P&P]. Photographed by Savage & Ottinger, Salt Lake City.*

a fifteen-minute chorus from the steam horns of twenty-one locomotives, ear-piercing whistles from all of Sacramento's foundries and flour mills and the ringing bells of all its churches. The music of eight bands stationed at various intersections competed with all the other noise. Behind the flag-festooned carriages of CPRR's executives stretched a two-mile procession of wagons, fire engines, marching bands and hundreds more on foot or horseback. Daylong festivities closed with nighttime bonfires and fireworks.

Charles Crocker and family booked passage on the first passenger train headed eastward, en route to a long-earned recuperative vacation in Europe. Before committing to the railroad endeavor, the successful dry goods merchant had built a palatial mansion for his family at Eighth and F Streets. He claimed he spent only three nights under its roof during the six years the Central Pacific Railroad was under construction. Today, the former site of Charles Crocker's home is occupied by the Sacramento County Recorder's Office.

The first rail shipment from California was one hundred barrels of flour from Sacramento's Pioneer Mills on June 2, 1869, bound for Salt Lake City.

The Central Pacific Railroad

IMPORTANCE TO SACRAMENTO

The impact of the transcontinental railroad on Sacramento's economy was enormous. By the turn of the century some thirty years later, railroad activities directly and indirectly employed an estimated 20 to 30 percent of salaried workers in a population of fewer than seventy thousand.

The Central Pacific received its first locomotive in October 1863, christened the Governor Stanford. It was manufactured in Philadelphia, shipped around Cape Horn and arrived in Sacramento aboard the river schooner *Artful Dodger*, ready to be reassembled. With no facilities of their own to assemble, repair and maintain equipment, railroad officials hired mechanics employed by Goss and Lombard, a foundry near Second and I Streets. A month after the arrival of the Governor Stanford, the CPRR began work on the first of its shops, located on the north shore of Sutter

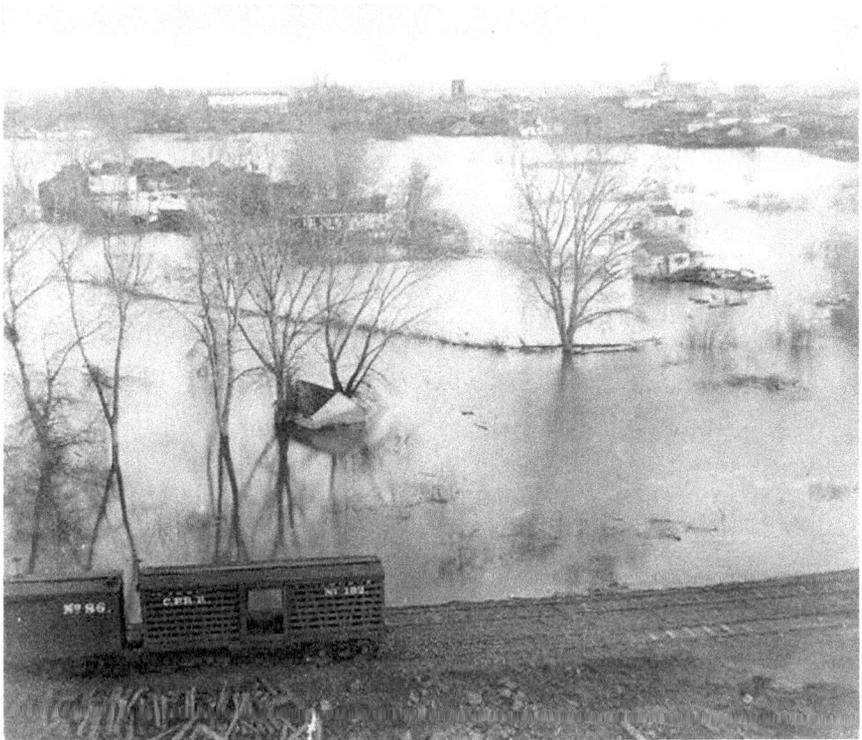

Sutter Lake, aka Sutter Slough, circa 1866. Note the railroad cars in the foreground. *Courtesy Library of Congress LOT 3544-31, no. 1202.*

Lake adjacent to I Street between Second and Sixth Streets. Limited operation began in six months, eventually growing to a mammoth sprawl of buildings that housed several foundries; copper and tin shops; boiler and blacksmith shops; locomotive and car machine shops; paint, upholstery and cabinetmaking facilities; office space; and a depot that allotted a portion of its space as a hotel.

Following some mergers and acquisitions, the Central Pacific was reorganized as the Southern Pacific. The renamed Southern Pacific Railroad Shops in Sacramento produced over two hundred locomotives, rebuilt or modified others, constructed Tourist Sleeper Cars for transcontinental traffic, built thirty box or flat cars per week, overhauled steamboat boilers and built the huge engines used in ferryboats. One of the finest passenger cars constructed in the shops was the private car built for Leland Stanford in the 1880s. Stanford, president of the Central Pacific, was a central figure in developing a cable car line in San Francisco. The equipment for this operation was manufactured in the Sacramento railroad shops, also in the 1880s.

Over the years, the partially filled-in land adjoining Sutter Lake, or Slough, became a serious health hazard. Used for decades by citizens as a dumping

Southern Pacific Shops steam locomotive. *Courtesy Library of Congress HAER CA-303-K-1, image created by Jet Lowe.*

ground for sewage, the once-pleasant body of water was a breeding place for rats and mosquitoes. Debris from the shops also polluted the lake, and leakage from nearby oil storage tanks spread a layer of oil on the surface. An accidental, yet disastrous, fire raged over the slough in 1906, prompting the company to complete the reclamation of Sutter Lake, as it had agreed to do when the city initially granted the land. The shops produced their last locomotive in 1937.

Part VI

\mathcal{A}griculture

John Sutter was Sacramento's first farmer. Innovative and resourceful by necessity, he made do with what was available in the wild. Dried acorns became a substitute for coffee. Trial and error taught him the value of irrigation as he planted wheat, barley, peas, potatoes, onions and melons in the fertile valley soil. Before he purchased the Fort Ross farming implements, he harvested wheat with pocketknives and strips of barrel hoops. Sutter built a crude but effective gristmill to grind his wheat into flour, the only one in the entire Sacramento Valley until 1846, when his former employee Jared Sheldon built another one in present-day Sloughhouse.

In late December 1847, a month before the gold discovery, Sutter enthusiastically planted two thousand fruit tree saplings acquired from Napa Valley in prepared trenches on the fort's acreage, trees that withered and died when his gardeners deserted him for the gold fields. But except for Sutter's agricultural pursuits, the private-use gardens and fields on coastal ranches and crops grown by the sixty or so pioneer families who settled in the Sacramento Valley between 1841 and 1848, there was no developed agriculture in California when gold rushers by the thousands swarmed into the northern regions. Foodstuffs, unappetizing after long sea voyages, were brought in by merchant ships and sold at exorbitant prices, inspiring luckless miners with prior farming experience to abandon prospecting for a surer fortune in planting greens and fruits. Since the remote foothills were not viewed as ideal garden spots, Sacramento's climate attracted a number of agricultural enthusiasts from

The 1840s gristmill and farming tools at Sutter's Fort State Historic Park. *Photo by author.*

the early years of the gold rush. The *Sacramento Transcript* reported on February 1, 1851:

> *EARLY VEGETABLES—Nicholas Watson, Esq., of this city, laid upon our table yesterday a fine bunch of radishes, well grown, raised by him in the vicinity of Sutter's Fort, where he has forty acres under cultivation, upon which vegetables of every description may be seen in a very nourishing condition. If more persons would give their attention to agricultural pursuits it would not only benefit them, but the country at large.*

PIONEER NURSERIES

Anthony Preston Smith arrived in Sacramento in July 1849, having sailed with a group of hopeful prospectors from New York, where Smith had operated a horticultural farm for several years. In December, he purchased

Cherries, ready to pick. *Photo by author.*

a fifty-acre tract from John Sutter and made plans for developing gardens and orchards. He is not listed in early Sacramento directories, probably because his property was east of the then city limits at Thirty-first Street (Alhambra Boulevard). His vegetable seed gardens were producing by 1851; he pioneered the production of fine-quality peaches and is credited with producing the first raisins in California. Increasing his holdings to ninety acres, Smith also cultivated apples, pears, plums, cherries, nectarines, apricots, pomegranates, figs and walnuts and a variety of grapes, as well as ornamental and timber trees.

The grounds were irrigated by a ten-horsepower steam pump that threw ten thousand gallons of water an hour into a reservoir that carried it through 6,000 feet of pipe, twenty hydrants and 4,500 feet of canvas hose. The flowers and shrubs from his three greenhouses, each one 100 feet long, plus his fruits and vegetables, captured state fair medals for years running. A.P. Smith's Pomological Gardens was a favorite suburban pleasure resort that drew day-excursionists who blissfully traversed two miles of meandering walkways covered with crushed shells imported from San Francisco. Smith realized $40,000 in profits ($2 million adjusted for inflation) in one three-

year period. His produce brought premium prices; his fresh strawberries sold in 1857 for the modern equivalent of $75 per pound.

The fabulous, award-winning A.P. Smith's Pomological Gardens was just one victim of the valley-wide 1861–62 flood, when the American River surged through the levee at Thirty-first Street, sweeping away some five hundred feet of Smith's property, including his stately family home. Courageously, Smith rebuilt. But Smith's Pomological Gardens, once an important component of Sacramento's agriculture, was damaged again in the Christmas week floods of 1871, never recovered its former glory and faded into obscurity.

In 1851, German immigrant Jacob Knauth established the once famous Sutter Floral Gardens on the western bank of Burns Slough near J and Twenty-ninth Streets as another pleasure garden laid out in handsome style with serpentine walks, arbors and summerhouses. A year later, he imported vine cuttings, bulbs and flowering plants from Europe and built a 150-foot-long greenhouse. By 1858, he was making wine of excellent quality, winning a state fair premium. Irish-born Thomas O'Brien, head gardener for A.P. Smith since 1850, established the Rosedale Nursery in 1854 between B, D, Twenty-fifth and Thirty-first Streets, taking special pride in his varieties of roses, variegated verbenas and five acres planted in asparagus.

During the catastrophic 1861–62 floods, O'Brien escaped personal injury but lost his residence, greenhouse and many fine trees when the freight-laden steamer *Gem*, propelled by strong currents on the American River, burst through a levee break in late January 1862, skidding to a stop in his orchard some four blocks away. A month earlier, Jacob Knauth had frantically rescued just twenty-five pipes of wine (a pipe is a unit of approximately 126 gallons) before rising waters collapsed his cellar walls, burying the remainder. On January 10, floodwaters rolled over his premises, sweeping away the wine he had saved and depositing three to four feet of sediment. O'Brien, rebuilding at the same location, was still in business in the 1870s. Sutter Gardens suffered a total loss. Knauth himself, however, recovered. In the 1870s, he was superintendent of the Gerke Winery on Eleventh Street.

Horticulturist and merchant James L.L.F. Warren came to California in 1849 as a gold rusher but soon moved to Sacramento, where he opened Warren & Co., purveyor of general merchandise, groceries and miner's goods, and his New England Seed Store on J Street. The New England Seed Store offered seeds, shrubs, fruit and ornamental trees and bulbs. Warren introduced the camellia, for which the city is now famous, to Sacramento in 1852. That same year, he sponsored an exposition of nursery products

Almost ripe pears. *Photo by author.*

and mineral collections at his seed store, offering prizes for outstanding entries and lectures on various subjects. His Great Agricultural Fair was so successful that he held a larger show in San Francisco the following year. He relocated there permanently as Warren & Son after his nursery was destroyed in Sacramento's April 1853 flood. In December 1853, James Warren announced he would publish *The California Farmer and Journal of Useful Sciences*, to "furnish...readers the most useful data for the practical agriculturist, and to present...all the most important practical results, obtained from authentic sources." Warren named Dr. John F. Morse as editor; Morse was formerly the editor of the *Sacramento Union*.

He didn't stop there. Undaunted by the fact that legislative representation of mining districts outweighed that of agricultural interests, Warren lobbied and prodded legislators, arguing that it was absurd to continue spending millions of dollars annually on imported foods when more efficient agricultural programs would better secure economic and social stability. His views were echoed by many. At a time when generous-sized residential city lots had yet to be filled in with rows of houses, pioneer settlers took pride in their home garden patches of cucumbers, corn, squash, melons and assorted fruit trees.

Cornstalks in a private garden. *Photo by author.*

By 1858—ten years beyond the gold discovery—120 individuals in Sacramento County owned orchards containing one hundred trees or more, and the total value of fruit raised showed an increase of 219 percent over the previous year. The Sacramento County assessor enumerated the thousands of pear, nectarine, apricot, plum, quince, cherry and fig trees; a growing number of citrus and nut trees; and 304,345 strawberry plants. The number of apple and peach trees was only surpassed by the number of grape vines. Nurserymen formed their own association, vowing in a declaration signed by A.P. Smith of Sacramento to combat "tree-peddlers," purveyors of dubious quality and mislabeled fruit and ornamental trees from the backs of their wagons. The steady increase in Sacramento County's agricultural output did not go smoothly, of course. In succeeding decades, crops of all types suffered from too little or too much rain, various diseases and insect infestation. Olive growers once despaired of finding adequate markets for their product. Local vineyardists experienced increasing competition from Napa Valley, Southern California and other locales.

Despite denials by mining interests, agriculture had outstripped gold production as the dominant economic force by 1880. Toward the end of that decade, the *Sacramento Daily Union* claimed Sacramento County as the Garden

Spot of California, stating, "There is no [agricultural land wasted] in Sacramento County...except for a few fields kept for grazing all is under cultivation."

Wheat was California's new gold from the late 1860s, grown throughout the state in favorable climates. Mechanism kept pace. Manufactured mowing and threshing machines drawn by more than thirty horses were available to farmers from the mid-1850s, replaced within ten years by steam-powered farming machinery. John Sutter's wheat fields along the American and Sacramento River bottoms had long since been covered by city development; instead, great quantities of the golden grain waved for twenty miles between today's Sacramento-Folsom light rail bed and the Cosumnes River, from the lower Stockton Road to the eastern foothills and on huge ranches north of the city, where just eighty-two "wheat barons" controlled approximately one million acres—one-fourth of Sacramento Valley's total acreage. Wheat farming was the backbone of the valley's economy from 1867 to the mid-1880s, until the invention of refrigerated railroad cars allowed fruit to outpace wheat as the valley's most valuable crop. Between the 1880s and early 1900s, many of the large wheat farmers were in debt. Upon their deaths, heirs subdivided and sold the property in smaller parcels, which in turn led to the development of rice and alfalfa fields in the central valley flood plains.

Agricultural Society and the State Fairs

Finally recognizing the state's immense agricultural potential, the legislature, by a special act, incorporated the California State Agricultural Society on May 13, 1854, to promote California's nature-based industries. From that date, the society sponsored annual, statewide agricultural exhibitions; its successor agencies, over the years, evolved into the current California State Fair. From inception, the society dispatched visiting committees to examine all farms, orchards, vineyards, nurseries, field crops, mining claims and mills throughout the state that might be entered for competition at the annual fairs. Their published reports added immeasurably to a wider knowledge of agricultural techniques.

The fairs traveled between San Francisco, Sacramento, San Jose, Stockton and Marysville until 1859, when Sacramento became the site of all subsequent exhibitions and of the Agricultural Society's permanent

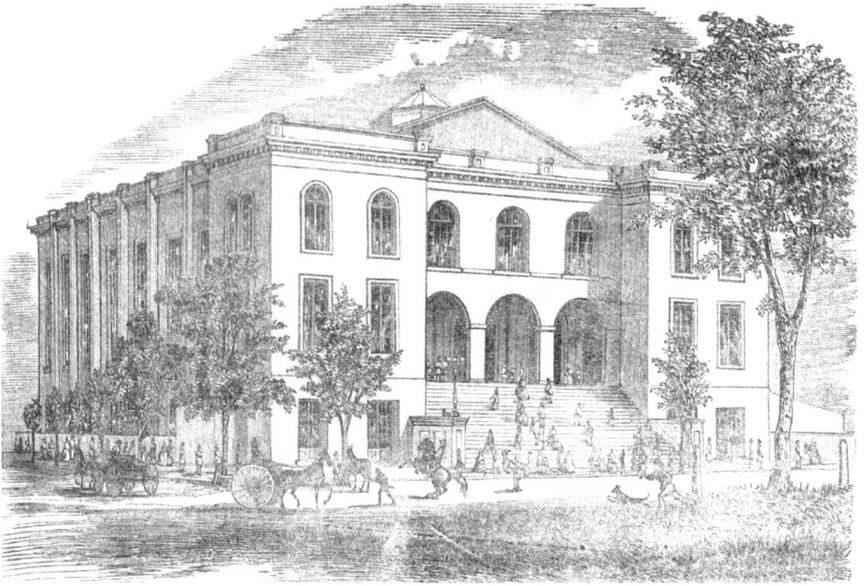

State Agricultural Society Pavilion, 1859. *Courtesy California History Room, California State Library, Sacramento.*

offices, at its Pavilion on Sixth and M Streets. Completed in forty-four days, the Romanesque-style masonry structure boasted the largest public room in the United States, with twenty-three broad steps from the street to its arched doors and windows. Five chandeliers illuminated the Main Hall; the largest, in the center, contained fifty-six gas burners. Projecting wings held committee rooms. It was, as both the *Union* and the 1860 city directory crowed, the pride and joy of the city. The society's Agricultural Park, opened in 1861, featured a large Machinery Hall, cattle stalls and horse stables, roofed sheep pens, poultry houses and a grandstand where spectators viewed horse and dog races. The park and racetrack spanned B through H Streets between Twentieth and Twenty-third.

A second, even more magnificent Agricultural Pavilion—the largest public building in California—replaced the original hall in 1884. Located east of the Capitol on spacious grounds, the structure was designed in the shape of a Greek cross with two main halls; four circular, glass-enclosed conservatories nestled in the outer corners between the wings; and a fountain in the center of the first floor. Skylights on all the rooftops and a central dome of glass thirty feet in diameter afforded ample daylight. Like its predecessor, the new pavilion was the site of charity balls, concerts and conventions, as well as annual state fair exhibitions.

Agriculture

The new pavilion served for fifteen years, until growth in population and attendance at state fairs forced a change of venue to eighty acres on Stockton Boulevard, expanded by another seventy-five acres in 1937. For five years during and after World War II, the fair was suspended. In 1948, the state purchased a large tract along the American River, but construction on this land was delayed until 1963 while the fair continued at the Stockton Boulevard grounds. Known as Cal Expo, the current California State Fair site hosts many other events year round.

Hop Fields

The agricultural feature most nostalgically recalled by longtime Sacramento residents is the once-vast hop ranches; some were still standing tall into the mid-1960s. Viewed from a passing car, the rows of broad-leaved, dark-green vines appeared to spiral upward on sparkling, lattice-like strings arranged in a diamond pattern. Inside the field, the eighteen- to twenty-foot-high supports interlaced with a network of wires

Rows of growing hops. *Tom Myers Photography.*

looked more like a gigantic spider web. The climbing vines are gone now, but for nearly one hundred years hops, an essential ingredient in beer brewing, were a major Sacramento Valley industry.

Hop culture was first introduced to Sacramento in 1857 by brothers Daniel and Wilson Flint, who started with a 16-acre parcel a mile and a half south of the city. Within thirty years, Sacramento County was producing 30 percent of the entire Pacific Coast crop. In 1894, Sacramento County was the largest producer of hops in the United States. Hop yards stretched for mile upon mile along the banks of the meandering American River—south beyond the town of Perkins and eighteen miles east to Sloughhouse on the Cosumnes. Farming organizations large and small cultivated hops, but certain names achieved prominence: the Flint brothers; A. Menke, who owned 110 acres of hop ranches south of today's Sacramento State University campus; and Emil Clemens Horst. At one time, Horst owned the largest hop acreage in the world, with fields in British Columbia, Oregon and California. His 680-acre Horst Hop Ranch was located twelve minutes by car from downtown Sacramento, where the Campus Commons community of homes, shops and businesses now sits.

Because hop picking paid nearly double the wages to unskilled workers than any other field labor, growers attracted men, women and children in droves during the six- to seven-week harvest season that began in mid-August. Horst, and others, provided tents for laborers to rent cheaply, plus latrines, free fuel for cooking and wells sunk at convenient points. They arranged for city merchants and restaurants to open general stores and food concessions on site and sponsored frequent free "Hop Dances," importing musicians from Sacramento at their own expense. Horst liked to say that his industry offered "healthful, open-air employment," but pickers labored seven hours a day beneath a brutal late-summer sun, and the plants left a sticky residue on their hands at best and a poison oak–type rash at worst.

Horst and his fellow growers also liked to say that practically no other agricultural industry put as much money in circulation among the working classes. Perhaps so, but this premium pay exacerbated racial resentment and labor issues already prevalent in other agricultural harvests, whether it was almonds in the Sacramento–San Joaquin Delta or fruit orchards in the valley. During the 1890s, Sacramento newspapers waffled pro and con, decrying the presence, in the hop fields, of various ethnic groups. Editors pointed out that Piute Indians taking the train from Reno to work in Sacramento hop fields were the offspring of fathers who, a mere generation earlier, were murdering whites who passed through Nevada Territory. Local merchants

Mechanized hop harvest in the twentieth century. *Tom Myers Photography.*

resented the Chinese pickers, maintaining that they didn't benefit one cent because Chinese hop gatherers sent all their earnings back to China. Controversy raged over "alien workers" displacing white American workers. Yet by the end of the decade, most of the hop picking in Sacramento was done by Japanese labor because white laborers, as a class, were deemed too lazy and unreliable.

Weary of all these issues in an industry where labor was two-thirds of a grower's production costs, E. Clemens Horst revolutionized hop picking with his mechanical hop-picking machine in 1909, an invention that initially was the size of a small house. Although development costs amounted to $40,000 in 1909 dollars, the expectation was that one machine would do the work of twenty-five men. Horst introduced it in his Sacramento yards that year, nearly causing a riot when over two thousand job applicants arrived at his Perkins ranch along the American River and were told the picking would be done by machine. Several "regulars" angrily seized teams and wagons, threatened to sabotage his invention and declared a general strike on all of Horst's Sacramento yards. With his crop at stake and the kinks on his new machine not entirely resolved, Horst acquiesced to their demands. The next year, however, he was fully mechanized.

A much more famous hop riot occurred four years later at Wheatland in the northern valley, on the non-mechanized Durst Ranch. Mob anger

over inadequate sanitary facilities and the pay rate the Dursts were offering—allegedly incited by a number of Industrial Workers of the World members from Sacramento—threatened to become violent. An ill-considered gunshot, fired to quiet the rabble, resulted in twenty more shots, killing four men, including two pickers.

THE BIG TOMATO

The plant that Sacramento is most closely associated with is the tomato—that plump red fruit decreed as a vegetable of many varieties. "Sacra-tomato," or "Sack-o'-tomatoes," as wags nicknamed the city, once had several canneries where huge, open-bin trucks disgorged tons of this ripe produce. The location was a natural. From the 1850s, the city was an established river, wagon road and rail transport hub, surrounded by rich-soiled farmlands that produced 35 percent of the state's agricultural yield. Canned foods became Sacramento's major agricultural output.

As noted in the 1930 Sacramento city directory, Sacramento County's twenty canneries constituted the region's principal industry at that time, processing a multitude of farm products, of which tomatoes were the best known. Sacramento's inner-city plants were the largest in California; two of these were the largest in the world. Subsidiary industries manufactured tin cans and lug boxes. The directory's editors viewed the recently completed American Can Company plant at Thirty-third and C Streets as a validation of Sacramento's "canning center of the state" position.

In the early 1900s, the Chicago firm Libby, McNeil & Libby had built a nine-acre cannery complex at the juncture of Thirty-first and R Streets and Stockton Boulevard, a site served by the Southern Pacific and Sacramento Northern Railroads. The California Packing Company (Cal-Pac), incorporated as a combination of five West Coast companies, owned four Sacramento canneries located at Front and P Streets, Third and X Streets, Nineteenth and R and "Plant 11" at 1701 C Street, completed in 1925. Cal-Pac, best known for its Del Monte brands, eventually changed its name to the Del Monte Corporation. In 1931, Tom Richards and brothers Peter and Henry Bercut purchased an existing cannery facility just south of the American River on North Seventh Street. The Bercut-Richards Packing Company became the single largest producer of tomato products in

Agriculture

Women sorting tomatoes on a cannery conveyor belt. *Tom Myers Photography.*

the region, distributed under its own "Sacramento" brand. Collectively, the canneries employed hundreds of full-time staff and thousands of seasonal workers, mostly women.

Working there was no easy job, though it paid better than farm labor. From early June through fall, seasonal wage earners toiled as tomato sorters and vegetable packers or as overseers on the canning line itself amidst steaming vats and clanking machinery. Canning requires pressure-cooker temperatures. Wherever their work stations, workers daily inhaled the heated, heavy aromas of syrupy fruits and herbed, vinegary tomatoes that permeated every nook and cranny of the plant. There was no air conditioning. Instead, rows of top-hinged windows gaped open day and night to allow whiffs of fresh, heat-regulating outside air to circulate. Women especially complained that no amount of scrubbing could remove the stink and stain in their hair, clothes or skin.

Sacramento's city canneries were economic mainstays and major employers for decades, until public preferences shifted toward frozen foods and fresh fruits and vegetables. Simultaneously, improved canning mechanization required fewer workers. In the early 1980s, canning giants Del Monte, Bercut Richards and Libby, McNeil and Libby all closed their doors. Former cannery workers and workforce newcomers alike steadily

found work in the increasing number of positions available in city, county, state and federal agencies.

Today, government and transportation are the largest sectors of employment, although information and technology industries, financial activities and professional services draw significant numbers from Sacramento's labor pool. Nonetheless, the silly sobriquets inspired by the tomato in decades past are still in use.

OTHER AGRICULTURE

Sacramento's longtime premier creamery, Crystal Cream and Butter Company, was founded in 1901 by George and Caroline Knox, who churned fresh butter in the back of a small grocery store at 728 K Street. Twenty years later, Danish immigrants Carl and Gerda Hansen purchased the operation, still limited to butter and cream. In 1931, Crystal offered Sacramento its first bottled milk, delivered on doorsteps in protective wired crates. Over time, Crystal's products expanded to include cottage cheese, sour cream, ice cream, whipping cream, chocolate imitation ice milk and yogurt. In 1951, the company created the flower-skirted, smiling Crystal Dairy Maid iconic commercial art that graced selected Crystal labels and signage for fifty years. Dairy ranches in the Sacramento Valley supplied their raw goods. Crystal Creamery, the largest dairy manufacturer in the area, operated its eight-acre plant and office complex at 1013 D Street for over ninety years, finally moving manufacturing functions to a new state-of-the-art bottling facility east of Power Inn Road in 1996.

In January 2007, the company announced its intention to sell the D Street acreage to a local land developer, with plans to lease back the space from the buyer through 2008. Then, in a somewhat surprising move to their four hundred-plus employees, the Hansen family sold the business to Massassachusetts dairy products firm HP Hood in May 2007. That company resold it five months later to family-owned Foster Farms, headquartered in Modesto. Layoffs of Sacramento workers commenced in October 2007, although according to newspaper accounts, Foster Farms transferred seventy trucks, fifty-five drivers and thirty distribution employees to Modesto. The Crystal brand has survived, but the old 537,000-square-foot plant fell to the bulldozer at last. At present, all that

An almond orchard. *Photo by author.*

is left of Sacramento's signature home-grown company is an immense pile of rubble behind industrial fencing.

The California Almond Growers Exchange (CAGE) was founded in Sacramento in 1910. Four years later, CAGE established an almond-shelling plant, the only one in the world as of 1930, at Eighteenth and C Streets close to a railroad spur. By the mid-1950s, the plant was a busy operation boasting a substantial rise in its number of employees. In 1982, CAGE acquired the defunct, adjacent Del Monte plant. The company officially changed its name to Blue Diamond Growers, Inc., in 1987. Utilizing innovative processing techniques, aggressive advertising and development of new markets in chocolate candies, ice creams, baked goods and, later, McDonald's Asian Salad, the company expanded its successful operation worldwide. The Sacramento plant remains the world's largest almond factory and a California landmark. Blue Diamond's Almond Plaza Visitor Center and gift shop are popular tourist stops.

In the first decade of the twentieth century, four Sacramento ostrich farms provided ostrich plumes for ladies' high fashion hats and fans. Two of these farms were on K Street, a third on F and the fourth at W and Tenth Streets.

A Metropolis—Expansion and Innovation

ELECTRICITY: FOLSOM POWERHOUSE 1895

Before 1879, Sacramento citizens already used electricity in small amounts provided by storage batteries for the telegraph, fire and burglar alarms and stable and house bells. Beginning in 1879, that newfangled invention, the telephone, was added to the list. All of them together were enough to support two local electrical works that manufactured and installed such equipment. The great novelty occurred later that year during State Fair Week when Weinstock and Lubin's Mechanics' Store on K Street arranged a spectacular display of arc light powered by a steam-driven machine. Equal to four thousand candles, the output was applied to two lights placed in front of the building, producing a brilliant illumination witnessed by a curious crowd of about five thousand. Most spectators thought the current was too strong to ever be practical for lighting homes and businesses.

Yet four years later, developments in the field of lighting had progressed enough to interest investors in the commercial possibilities of an electric system in Sacramento. Proposals, opinions (the whole matter was "a humbug piece of business") and reservations concerning public safety around wires were voiced by the City Board of Trustees, which nevertheless passed ordinances in favor of two competitors to erect and maintain electric wires on poles or painted posts: William Muir, who immediately incorporated the

Sacramento Electric Light Company, and Addison Waterhouse, returning from several years on the East Coast, an attorney-turned-inventor who had, as a boy, arrived in Sacramento forty years before in a covered wagon. Now known nationally as one of "Edison's rivals," Mr. Waterhouse established the Pacific Electric and Motor Company. Both organizations used steam generators, the only power source available.

Ten years passed. While arc lighting for Sacramento streets and stores became commonplace, extensive experimentation continued because steam relied on coal, an expensive commodity. Some dreamed big. Horatio Livermore, president of the Natoma Water and Mining Company, and Albert Gallatin, founder of the Citizens Gas Light and Heat Company of Sacramento, joined forces to develop a hydroelectric power system.

Years earlier, Mr. Livermore's company had built a dam on the American River near Folsom to form a still-water basin for logs floated downriver to a sawmill, a venture that proved disappointing. Now, the newly formed Folsom Water Power Company began negotiations with Thomas Edison and Thomson-Houston's merged New York conglomerate, the General

The Folsom Powerhouse, Sacramento's first hydroelectric power station, today a State Historic Park. *Courtesy Library of Congress HAER CAL, 34-FOLSO.V, 2—10.*

Electric Company, for construction of its hydroelectric plant near this dam, although few such facilities existed. Work on the powerhouse foundations began in October 1894. The transmission line, using 2,600 redwood poles, followed the country road from Folsom to M and Thirty-first Street in Sacramento and from there jogged north, then west, to the Sacramento Electric Power and Light Company's station at Sixth and H Streets, better known to locals as the Gallatin and Livermore plant.

In the gray pre-dawn of Saturday, July 13, 1895, a telephone call from the Folsom powerhouse to the substation in Sacramento announced that all systems were ready. At 4:11 a.m., a detachment of Battery B fired a one-hundred-gun salute. Mr. F.O. Blackwell, a young engineer employed by General Electric, later praised for his cool air of command, manipulated the machinery inside the substation. The spinning, water-powered turbines upriver fed power to thousand-horsepower dynamos, which transformed the power into electricity at a potential of twelve thousand volts—one hundred times greater than necessary for a strong electric lamp—the highest ever employed for power transmission.

That morning, plentiful, cheap electric power was a reality in Sacramento, received from twenty-two miles away, the longest transmission of electricity in the world.

THE GREAT ELECTRIC CARNIVAL

Some, but not all, of the streetcars powered by steam-generated electricity converted to the new power later that day, and prominent Sacramentans began enthusiastically planning for a celebration. The chosen date was Admission Day, September 9. An estimate after the event, based on tickets sold, concluded that at least thirty thousand visitors came to the Capital City from other towns to witness the Electric Carnival.

The night of September 9, every Sacramento street was decked with carnival colors. Red, green and golden-yellow lights blazed from public and private buildings; streamers, paper lanterns and bunting festooned storefronts and balconies. Elaborate arches adorned the streets. The State Capitol Building shone with electric lights outlining the façade and ribs of the dome; trees in the surrounding park were covered with green, gold and crimson "fruit."

The State Capitol Building ablaze with lights for the gala Great Electric Carnival. *Courtesy California History Room, California State Library, Sacramento.*

At eight o'clock sharp, a magnificent parade began. Buglers and brass bands heralded each division as the procession of mounted cavalry, National Guard companies, letter carriers from the Sacramento post office and brilliantly illuminated floats drawn by electric streetcars wended its way from Twentieth Street to the pavilion opposite the Capitol. Young ladies waved from atop the State and Fruit-and-Flower floats. The last and definitely most awe-inspiring division was composed of twelve floats from the Southern Pacific Railroad shops, each featuring ingenious arrangements of lights or mechanical equipment. The leading float was a model of an electric locomotive. The Cupola, entered by the Pattern and Foundry departments, depicted an immense smelting furnace, with smoke and flame simulated by lighting. Pretty girls threw castings in the shape of bears to the crowd as souvenirs.

Other offerings of the various shops included the electric hammer float, an illuminated sawmill running at full speed and an electric fountain that used an electric pump to spew fifteen streams of water three feet high. The sides of this float carried the slogan "Sacramento—City of Destiny." The winning entry from the Roundhouse and Spring Shop displayed the progress of illumination, with candles on the lowest level, followed by kerosene lamps,

gas jets and then electric lights. All of the intricate displays were on view at the pavilion during State Fair Week.

Yet despite the fantastic success of the Carnival of Lights, a large number of local citizens voiced their lack of faith in the capacity of the new power, possibly because not all consumers could be met with immediate supply. On the night of the carnival, not all the machinery at the substation was in place—including its distributing switchboard and a complete roof over its works. The "mysterious current" materialized slowly in homes and offices because the infrastructure for gas already existed, whereas electric power required new fittings and a maze of wires strung on poles. Naysayers' initial cautions faded away as the new power source contributed to city sprawl and enticing public amusements.

OAK PARK

The Roxbury Vineyard just below the extreme southeastern edge of Sacramento was the site of the city's first combined residential and business community expansion beyond the original grid laid out in gold rush days, a neighborhood historically distinct both as the first "trolley car" suburb and for its early 1900s amusement park.

Oak Park was developed in 1887 by prominent businessman-realtor Edwin K. Alsip, who was also secretary of the Central Street Railway Company. Despite advertisements extolling the "comforts of a city life without city taxes" at terms "within the reach of all" and the promise to immediately commence a cable road, early sales were slow. Speculators acquired lots; eighty-foot-wide avenues were graded and paved with macadam. Transport to the development was first supplied by horse-drawn trolleys. In 1889, after the Central Street Railway Company purchased about forty acres, Alsip announced plans to develop a resort and pavilion, with a steam-powered electric plant to light the premises and with picnic tables beneath the spreading oaks. The park marked the terminus of the streetcar line connecting the community to downtown Sacramento, allowing residents to commute to jobs in the city proper.

In 1891, horses were replaced by steam-powered electric trolleys, traveling the main artery of Sacramento Avenue, now known as Broadway. Further development of Alsip's envisioned "pleasure resort" was continued

Electric trolleys on K Street, circa 1900. *Tom Myers Photography.*

by subsequent owners, who added a grand entrance arch, entertainment facilities, a small zoo and food concessions.

About 1914, hydroelectric power spurred Ingersoll Amusement Company to invest hundreds of thousands of dollars into lavish improvements on the grounds to create Joyland, a spectacular amusement park that featured the Scenic Railway (a popular figure-eight rollercoaster), the Giant Racer ride, the Joy Wheel (Ferris wheel), a new carousel and other similar attractions. Sacramentans went there in droves; attendance records were shattered every night until, several years later, attendance waned. In 1927, Mr. and Mrs. V.S. McClatchy purchased the amusement park acreage, deeding it to Sacramento as a memorial park in honor of James McClatchy, the founder of the *Sacramento Bee*—as it remains today. On September 12, 1911, citizens voted for the annexation of Oak Park and burgeoning East Sacramento, an event celebrated with the Greater Sacramento Annexation Jubilee, replete with parades, races and barbecues.

EAST PARK

Before Oak Park became a reality, the Sacramento Street Railway Company, hoping to increase ridership on its horse-drawn H Street streetcar line, purchased and developed, in the early 1870s, thirty acres just across the eastern city limits along Thirty-first Street between E and H Streets, as a public recreation area. Development included partial reclamation of a meandering, swampy area known as Burns Slough. When complete—although the project remained "in progress" for many years—East Park boasted a fine lecture hall, pleasant walkways, up to six hundred evergreen trees, a bowling alley, a gymnasium, "refreshment saloons" and other amenities. East Park was a popular venue for picnics, dances, festivals, sporting contests and musical performances. More than once, crowds of spectators oohed at hot-air balloon ascension and parachute jump exhibitions—not all of them successful, although no one was injured. A permanent attraction was the toboggan ride, also known as the toboggan slide, an aerial electric railway (closed in the rainy months) that was among the first Sacramento amusements to switch to the new

McKinley Park pond, 2012. *Photo by author.*

hydroelectric power. Advertised as the longest of its kind in the country, East Park's toboggan cars hurled their passengers among the treetops, providing a "most exhilarating experience." The toboggan ride, a national craze in that era, also enriched Sacramento merchants who stocked crocheted toboggan caps or miniature toboggan slides as children's toys.

East Park was later renamed McKinley Park in honor of assassinated president William McKinley. Developers began planning suburban tracts on the outskirts of the park, extending the electric grid when McKinley Boulevard Tracts 1 and 2 were subdivided and planned in the late 1920s. Developers purchased and surveyed the land and installed streets and utility infrastructures, but lot buyers hired their own building contractors. McKinley Park at 601 Alhambra Boulevard, with its one-and-a-half-acre rose garden and Arts Center, is a centerpiece for the individually styled homes around it. A large pond, where ducks and geese gather to groom their feathers and coax dry bread crumbs from visitors, is the only vestige left of Burns Slough, a natural watercourse that was so troublesome during nineteenth-century floods.

BOULEVARD PARK

In 1905, Wright and Kimbrough's Park Realty Company acquired the Agricultural Park and racetrack grounds between Twentieth, Twenty-third and B through H Streets to create Boulevard Park, the first large-scale residential development designed for the upper middle class. Characterized by large lots and wide streets with grass "parkways" running through their centers, Boulevard Park attracted upscale buyers with advertisements extolling cement sidewalks, preplanned park grounds abutting corner lots and promises to exclude stores, wood yards, saloons and other "objectionable features" from the neighborhood. Over time, portions of the large lots were sold and filled in with other homes. Today, Boulevard Park is a lovely, quiet, tree-lined midtown neighborhood that is enjoying revitalization.

THE FABULOUS FORTIES

Undeniably, Sacramento's most famous residential gem is the grand neighborhood renowned as the Fabulous Forties. Known as Tract 24 on plated city maps in 1913, the gold rush–era pioneers knew this elevated ridge of land between J and R and Fortieth and Forty-fifth Streets as Oak Hill from the early 1850s through the late 1860s. Farms, ranches, grain fields and orange groves dotted the landscape. The Oak Hill House, a restaurant on the planked road to Placerville (an extension of J Street), was a favorite gathering place. Even then, the area was home to prominent citizens. Horticulturist James L.L.F. Warren, the man who introduced the camellia to Sacramento and successfully lobbied the state legislature to create the State Agricultural Society, lived there at one time, as did Andrew Aitken, a pioneer marble works and granite dealer, and Dr. Phelan, the county physician in the mid-1860s. In 1866, committee members of the Agricultural College Commissioners investigated Oak Hill as a possible location for the proposed State Agricultural, Mining and Mechanic Arts College. (They ultimately chose the city of Berkeley.)

Realtors Charles Edward Wright and Howard Kimbrough are credited as the firm who developed the Fabulous Forties area and its wide, tree-lined streets beginning in 1913. Between then and the 1950s, vacant space still existed between some of the large, elaborate suburban mansions being built in the area bounded by Thirty-eighth, Forty-seventh, J Street and Folsom Boulevard. Today, the neighborhood contains a wide variety of historic, upscale, custom-built spectacular homes in a variety of styles—Tudor, Mediterranean, Craftsman, Italianate, English Revival, Caribbean and more—all reclining on beautifully landscaped and manicured grounds. Notable Sacramentans who have called the Fabulous Forties home include Carl Hansen of the Crystal Cream and Butter Company, the Breuner family of Breuner's Furniture, the owners of Ruhstaller's Brewery, the Adolph Teichert Jr. family and the Clausses of Clauss and Kraus meat factories. By far the most famous resident is former president of the United States Ronald Reagan, who resided on Forty-fifth Street during the years he was governor of California.

THE GOVERNOR'S MANSION

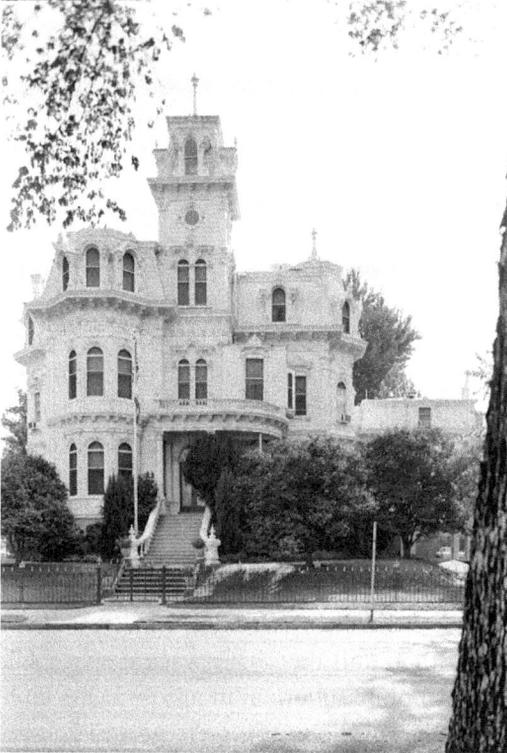

California Governor's Mansion, circa 1960. *Courtesy Library of Congress HABS CAL, 34-SAC, 19—3, photo by Jack E. Boucher.*

California governors lived in their own private homes until 1903, when the state purchased and furnished a property at the corner of Sixteenth and H Streets as a home for California's first families. The multistory, Victorian-era, Italianate-style residence was built in 1877 by Albert and Nemie (Clemenza) Gallatin. Albert, at age twenty-six, arrived in Sacramento in 1861 after spending a year mining in Siskiyou County.

He took a job as a clerk in the Huntington, Hopkins Hardware Store, then the largest hardware, iron and steel mercantile on the Pacific Coast. Gallatin owned his own successful hardware business in Nevada for a time and then returned to Sacramento in 1868 as managing partner, and later president, of Huntington, Hopkins while owners Collis Huntington and Mark Hopkins were engaged in building the first transcontinental railroad. He organized annual Sacramento Citrus Fairs, had interests in several agricultural and natural resources businesses and pioneered the development of hydroelectric power. Over the next thirty years, Gallatin organized and was the first president of the Citizens Gas Light and Heat Company of Sacramento, the Sacramento Electric Power and Light Company and the Central Electric Railway Company of Sacramento. Albert and his wife sold the residence, which history buffs still refer to as "Gallatin House," to locals Joseph and Louisa Steffens, who sold

it to the state sixteen years later. Occupied by governors and their families until 1967, the Governor's Mansion State Historic Park at 1526 H Street is a registered historic landmark.

The Resilient City

Indeed, Sacramento changed dramatically with each passing decade from its tumultuous birth at the waterfront in 1848. Culture in the form of newspapers, libraries, theater and benevolent societies—and official city government—was established while the thumps of gold miners' boots still reverberated through the streets.

Rebuilding and revitalizing itself after each fire or flood disaster, Sacramento moved forward with grit and determination. From 1853, a steady increase in the numbers of wives and children moving west brought more social stability, more churches and more schools. Rough-and-tumble

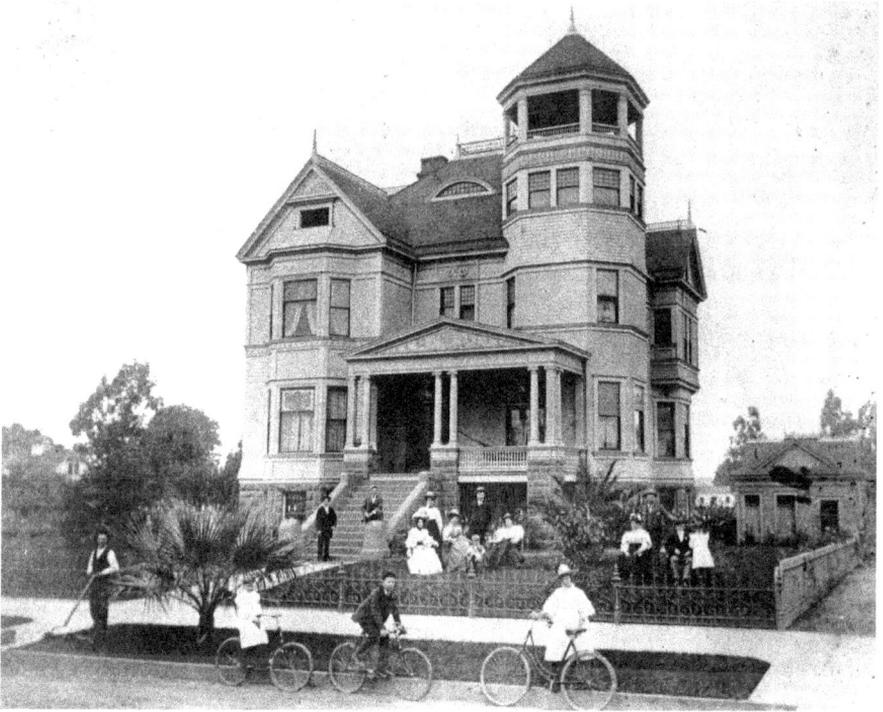

The Herman Grau family in front of their home on Poverty Ridge at Twenty-first and V Streets on the day of Adele Grau's wedding, 1896. *Courtesy Nancy Ware Family Collection.*

accommodations were replaced with sturdy business buildings, flourishing manufacturing plants and fine homes in exclusive residential neighborhoods. Elegant carriages rolled down city streets, drawn by handsome horses. Gaslight usurped candles and lanterns. A river ferry service between downtown and Washington, as West Sacramento was known for many years, provided transport to waiting stages bound for Napa and other points until 1858, when the first I Street Bridge was erected. Ordinances prohibiting livestock on city lots forced commercial dairymen farther outward into still-rural areas. Orchardists found expansion opportunities, and virgin soils, on open county lands miles outside of the ever-encroaching city.

Some historians claim that Sacramento skipped past adolescence entirely to become a mature city by 1871. In the following decades, residents grown wealthy from a variety of enterprises gave back to the community. The name of one noted philanthropist still resonates in Sacramento.

The Crocker Art Museum

Attorney (later Judge) Edwin Crocker and his wife, Margaret, came to Sacramento as newlyweds in 1852. After enduring the Great Fire and a flood the following year, they steadily prospered after Edwin became legal counsel to, and an investor in, the Central Pacific Railroad. The couple was well known about town as enthusiasts of cultural enrichment, and together they supported a number of charitable institutions. After Judge Crocker's death in 1875, Margaret emerged as a leading benefactress on her own.

Two of her interests were the further development of agriculture and aiding the underprivileged. Both goals were fulfilled when she purchased city lots across from the City Cemetery on Broadway in 1879 and built the Bell Conservatory, the largest hothouse in the interior, to experiment with exotic plants that might aid California agriculture—and also to provide the poor with free flowers to place on the graves of their departed loved ones. Along with this gift to the public, Margaret also donated lands for the enlargement of the cemetery. By then, talk had been circulating for some time about establishing a city-supported home for financially destitute elderly ladies of good character. Taking the matter in hand, Mrs. Crocker opened her own purse to purchase land and build the necessary facilities. The graciously furnished Marguerite Home for Aged Women at Seventh and Q Streets,

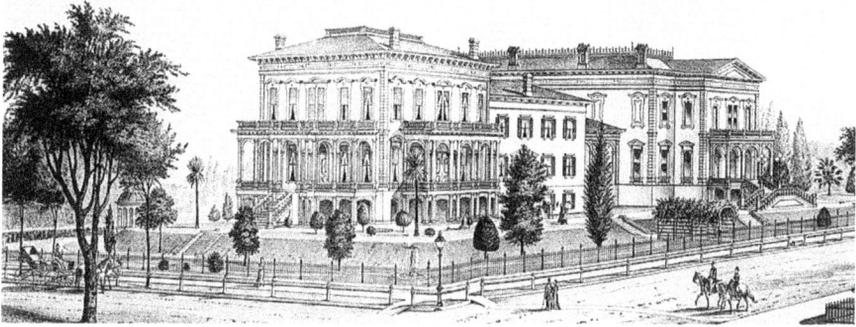

Artist's concept of the general plans for Judge and Mrs. E.B. Crocker's residence and art gallery, circa 1880. *Courtesy Library of Congress HABS CAL, 34-SAC, 20—1.*

surrounded by beautiful grounds, opened on the evening of February 25, 1884. In addition, Mrs. Crocker provided scholarships to deserving students of the Museum Association's Sacramento School of Design, supported Sacramento's Protestant Orphan Asylum and gifted the Cathedral of the Blessed Sacrament with a magnificent stained-glass window and other valuable glass for the entry.

By far her largest gift to Sacramento, in 1885, was the family's art gallery built adjacent to the Crocker residence on O Street. Acknowledged as the most fabulous private art collection in the western states, the Crocker gallery contained seven hundred framed paintings and over one thousand master drawings, collected over many years at home and abroad. An appreciative, ecstatic Sacramento paid tribute to Margaret Crocker, as no other private citizen has been honored before or since, with the elaborate Festival of Flowers on May 6, 1885, an event attended by more than fifteen thousand individuals. The Crocker Art Museum at 216 O Street, the longest continuously operated art museum in the West, continues the tradition of Judge and Mrs. Crocker's efforts to promote an awareness of, and enthusiasm for, the visual arts. The museum draws thousands of residents and tourists yearly to its permanent collection and special exhibits. The former Crocker mansion, a jewel case of nineteenth-century furnishings and architecture, is open to the public as well.

Modern Times

Automobiles began appearing in private driveways in the late 1890s, creating demand for a spreading network of new city streets and more stable bridges over the major rivers. Two bridges linking Sacramento to Yolo County across the Sacramento River opened in 1911: the first, M Street Bridge, built by the Sacramento Northern Railway, and a new steel truss swing bridge at I Street to replace the then fifty-three-year-old original structure. Work was completed on the Yolo Causeway in 1916 with one lane in each direction, allowing year-round automobile travel between Sacramento and San Francisco through a flood plain previously impassable in winter. The H Street Bridge, also known as the Fair Oaks Boulevard Bridge, spanned the American River to help connect Sacramento with new outlying communities—some later annexed to the city. Completed in 1933, the H Street Bridge is still a major commuter artery to and from downtown.

THE TOWER BRIDGE

Between 1910 and 1932, Sacramento's population rose from 45,000 to over 100,000 residents. Although the nation was in the midst of the Great Depression, cars became readily available in the early 1930s, shifting transportation from passenger trains to private automobiles. Cheaper cars,

known as "jalopies," were sold in the Sacramento region at record rates. As automobile traffic increased in volume and speed, the existing M Street steel swing span bridge erected in 1911 for railroads first (and vehicles second) was deemed terribly inadequate to handle the new heavy traffic over Highway 40, an emerging major east–west thoroughfare that ran through Sacramento to connect Lake Tahoe with the Bay Area. The railroad used the south side of the bridge and auto traffic the north, yet both shared the entrances to the bridge where trains switched tracks, causing delays and potentially dangerous conditions. Accidents multiplied; city officials and merchants alike saw the snarled traffic as detrimental to Sacramento's economy if it meant people would stop coming downtown to shop and conduct business. Also, Sacramentans took great pride in being the state capital and were eager to improve the appearance of the city's western access.

Plans for a new bridge began in earnest in 1932, with several city, state and federal agencies involved. Negotiations with the Sacramento Northern Railroad, which owned and maintained the M Street Bridge, resulted in the erection of a structure known colloquially as the "shoofly" bridge, a temporary wooden expansion of the I Street Bridge just upstream. Construction of the Tower Bridge commenced on July 20, 1934, by contractors George Pollock & Company. The cost was shared by the State Department of Public Works, the City of Sacramento and the Counties of Sacramento and Yolo, with an infusion of President Franklin Roosevelt's New Deal funds. Architect Alfred Eichler designed it with a vertical lift gate operated by two electric-powered motors enclosed in a cabin on top of the deck, the first vertical lift bridge on the California Highway System. The two towers are 180 feet high, and the deck can lift up to 173 feet to allow vessels on the Sacramento River to pass beneath. The project cost close to $1 million and generated about 1,500 direct jobs locally, with many hundreds more working in offsite mills and shops.

Opening dedication ceremonies took place on Sunday afternoon, December 15, 1935, beginning with a procession from the State Capitol Building. Sacramento-area Boy Scouts raised the American flag on the bridge; crowds of pedestrians jammed themselves into the structure itself to hear speeches and marvel as one thousand homing pigeons were released, each carrying a message announcing the "opening of the gateway to California's Capital City." Following the official ribbon cutting by Governor Frank Merriam, the vertical lift gate rose to its full height as a flotilla of boats and barges passed underneath with their horns and sirens blowing. The railroad tracks in the center of the Tower Bridge are gone now, as is old U.S. Highway 40.

The Tower Bridge, an oblique view looking southeast toward the city of Sacramento from the Yolo County side of the Sacramento River. *Courtesy Library of Congress HAER CAL, 34-SAC, 58—11.*

Initially painted aluminum-silver, the Tower Bridge was repainted a yellow-ochre color in 1976, intended to represent the gold-leafed cupola on the State Capitol that was visible ten blocks distant to eastbound motorists as they entered the city. When that paint job wore thin twenty-five years later, a choice of burgundy, green, silver and gold, or all gold, was put to a citizens' vote. "All gold" won, and the work was done, but some Sacramentans complain that the paint is not as gilded as they were led to believe when they voted. Still, the massive landmark Tower Bridge is visible for miles—particularly at night, when the floodlit structure fairly glows as a golden, iconic reminder of Sacramento's golden past.

Both the still-standing I Street Bridge, erected in 1911, and the Tower Bridge were added to the National Register of Historic Places in 1982.

PROHIBITION

Mark Twain called Sacramento the City of Saloons when he visited in 1866. Too young to participate in the gold rush himself, Twain surely learned that the saloons of those chaotic years (beyond dispensing astonishing amounts of liquor) were places where lonely miners met to exchange news and gossip. The use of drinking establishments as social centers persisted in subsequent decades, as workingmen crowded into taverns to enjoy spirits and to share camaraderie and executive types frequently popped in for a libation or two before heading home. With this background, it was hardly surprising that Sacramento resisted the Eighteenth Amendment.

Try as they might, neither 1850s temperance leagues nor their successors, the Women's Christian Temperance Union, the Prohibition Party and the Anti-Saloon Leagues of 1898–1908, ever squelched the San Francisco–Sacramento "whiskey belt." Sacramento saloon owners found these attempts irritating, to say the least. The *Sacramento Daily Union* of March 6, 1874 reported:

> *SALOON VISITING—The saloon keepers of the city were somewhat interested yesterday in a report that ladies had during the previous evening visited two saloons and exhorted the proprietors to cease that sort of business. Their visits do not appear to have been of much profit, and there is little reason to believe that that style of procedure in Sacramento will meet with much favor from any quarter. One or two saloons are reported to have been visited last evening.*

In 1910, there were more than 130 saloons within the city limits; Sacramento remained stubbornly, and staunchly, soaking "wet." *Sacramento Bee* owner and editor C.K. McClatchy, son and heir of the newspaper's founder, frequently editorialized against the growing "dry" agitation, prompting Sacramento voters to return overwhelming majorities against any such local measure. On New Year's Eve 1919, Sacramentans prepared for one last fling before the federal law went into effect the following January 17. (Actually, California's Wright Act had banned the instate sale, possession and transportation of alcoholic beverages since the previous July.) Intoxicants would not be *sold* that New Year's Eve, but the law made it known that it would look the other way if celebrants brought their own supplies. Better-heeled citizens had stocked their cellars in anticipation; ordinary folk, who may not have been interested in liquor before, now wanted a drink in defiance of what they saw as infringement on their freedom of choice.

Largely unhampered by a lax police force, bootlegging flourished. Citizens patronized "clubs" and purchased alcohol in "blind pig" back rooms behind legitimate storefronts. Gin could be made at home with alcohol purchased from a cooperative pharmacist, along with juniper berries and distilled water. Home brew equipment was openly advertised and sold. Rumrunners from Canada swooped in, selling good whiskey "right off the boat" at premium prices. Although no formal charges were brought against Sacramento law enforcement, "dry" agents of the State Law Enforcement League were accused of raking in hush money after a few good wine dinners, and a Sacramento Grand Jury thought it seemed odd that some police officers could afford big automobiles on public salaries.

And it was the automobile, of course, that made Prohibition even harder to enforce because thirsty souls in neighboring counties had only to drive into Sacramento, where enforcement was sporadic and ineffective.

Wisely, anti-Prohibition factions sidestepped any moral arguments on the Evils of Drink and instead campaigned on the obvious: the nationwide failure to enforce Prohibition. When repeal came on December 5, 1933, few in Sacramento mourned the demise of the "noble experiment."

AVIATION AND THE WORLD WARS

Into the 1930s, the Sacramento waterfront still bustled with commercial activity as incoming ships were met by trucking lines and rail cars on city wharfs. Aviation steadily gained enthusiastic support as a mode of long-distance transport and travel, and Sacramento's first airmail delivery in August 1927 was an important milestone. Sacramento Executive Airport on Freeport Boulevard (formerly Sacramento Municipal Airport) was originally known as Sutterville Aerodrome when it opened in 1930.

Two world wars brought a major influx in population to the greater metropolitan area: military personnel and others attracted by civilian jobs at the bases or employment opportunities at Sacramento's downtown canneries. Mather Air Force Base, originally an airfield and flight training school known as Mather Field, opened in 1918 on part of the former Rancho Rio de los Americanos Mexican land grant, purchased circa 1849 by Captain Joseph Folsom from the William Leidesdorff estate. Dormant for a period after the end of World War I, Mather Field reopened as a military facility just prior

to World War II. The army began construction of a new air depot in 1936 on acreage in the northern sections of the old Rancho del Paso. Soon to be named McClellan Air Force Base, and conceived as a supply and aircraft maintenance facility, the well-equipped base grew rapidly with the advent of war. During World War II, the army created a sub-depot on Broadway and Stockton Boulevard to reduce congestion at its San Francisco–Oakland Port of Embarkation. Later, the Signal Corps took charge of the depot, an important storage and repair location for communications equipment. The facility moved to temporary quarters at the Bercut-Richards packing plant inside the city proper at Seventh and North B Streets. At war's end, a permanent location for the Sacramento Army Signal Depot was constructed on Fruitridge Road, eight miles southeast of the capital.

The needs of these military installations pumped new life into Sacramento's economy in many ways: construction on the bases themselves plus new housing developments provided by local contractors, and a burgeoning number of support services firms. Although two of the bases were miles outside of the city proper, their employees motored into Sacramento for shopping and entertainment until a profusion of suburban centers began developing in the mid-1940s.

Major downtown department stores, large groceries such as the Food Depot at 1120 H Street, parks, restaurants and movie houses attracted thousands, especially on weekends. The central business district still lined J and K Streets, where Hale Brothers Department Store, Weinstock-Lubin, the Crest and Senator Theaters, the YMCA, Carnie's Sporting Goods Store and a host of now long-gone establishments flourished. The Tower Theater at Sixteenth and Y (now Broadway) opened in 1938.

THE ALHAMBRA THEATER

Gone since 1973 but still alive in many Sacramento citizens' memories, the lavishly appointed Alhambra Theater, designed by architect Leonard Starks in the Moorish style of old world Spanish citadels, opened in 1927 at K and Thirty-first Streets. First-run major films played there to a capacity crowd of 1,990 moviegoers who strolled across plush red carpets beneath vaulted ceilings and past ornate gold-trimmed pillars to find their seats. On the grounds outside, beautiful rose gardens and fountains enticed patrons

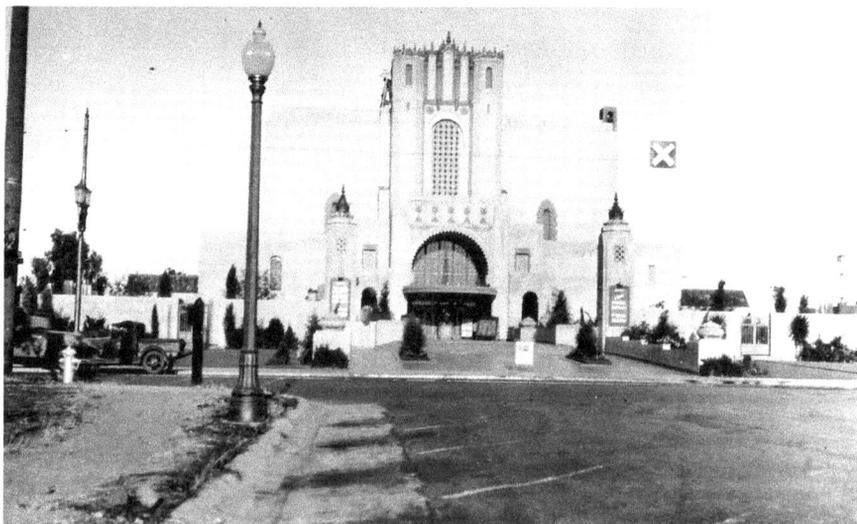

The Alhambra Theater viewed from K Street, the "Showplace of Sacramento" for forty-six years. *Courtesy California History Room, California State Library, Sacramento.*

to remain after the film ended. Known as the "Showplace of Sacramento," the Alhambra Theater was so splendid that the city renamed Thirty-first Street to Alhambra Boulevard. Decades later, when the structure was in need of extensive repairs, a bond measure to allow the City of Sacramento to purchase the theater failed to pass, despite considerable support from various public factions and private organizations. The Alhambra Theater was demolished in 1973 to make way for a Safeway grocery store and parking lot, fostering a local historic preservation movement that remains active, adopting "Remember the Alhambra" as its slogan.

In general, metropolitan-area expansion, improvement and demolition throughout the many decades of cityhood met with few restrictions. Caveats attached to the original core city laid out in late 1848 at the direction of Captain John Sutter's son, August Sutter, provoked contention for years.

The Founder's Bequests Disputed

A week before the newly mapped Sacramento city lots were auctioned in January 1849, August Sutter generously gifted ten well-placed squares—and decreed certain conditions—to the as-yet-unincorporated city in written

language that raised controversy from the early 1870s into the century following his death. Among these caveats was that all streets and alleys were to be kept open for public use. Further, the ten donated squares were reserved "for the public use of the inhabitance [*sic*] of said city to be applied to such public purposes as the future incorporated authorit[ies]…from time to time declare and determine." In Sutter's time, city limits were from A to Y and First (or Front) to Thirty-first Streets.

The ten town lots August generously donated to the city were: Marshall Park, Winn Park, Stanford Playfield, Grant Playfield, Fremont Park, the Memorial Auditorium block, Muir Children's Park, Roosevelt Park, City Plaza (now Chavez Plaza) and a square at the western edge of Alkali Flat. Nine of these ten property donations still exist at their original 1849 locations. The Alkali Flat square between B and C, Ninth and Tenth Streets was one of many parcels granted to the railroad for right of way in 1863, apparently with no protest from the Sutter family. The land was vacant until the 1930s, when Alkali Park Playfield became a recreation area for children amidst a growing industrial area. Further industrial expansion in the 1940s obliterated whole sections of city blocks northeast of D Street; August Sutter's designated gift square no longer appears as viable streets on current city maps.

Precedent for city ownership of August Sutter's gift blocks was set by the California Supreme Court in 1873, over a suit involving ownership of the Union Park Race Track (in Agricultural Park) partially built on the block bounded by B, C, Twenty-first and Twenty-second Streets. Then, in January 1924, the city abandoned sections of Seventeenth Street to allow for construction of a California Packing Company plant. The descendents of John Sutter Jr. promptly sued, contending that streets closed to public use for the benefit of private interests reverted to the Sutter heirs. Eleven years later, the California Supreme Court denied their claim, noting that between 1862 and 1921 some thirteen previous ordinances abandoning city streets in Sacramento had been passed without complaint. Over a period of years, the Sutter heirs and other claimants filed more litigation against the city, none ultimately successful.

In June 1924, after fifty-odd years as the site of Sacramento Grammar School (also known as the Watson School), a public educational facility, city fathers proposed to build an auditorium in the square between Fifteenth, Sixteenth, I and J Streets. Opponents took issue with the city's plan to charge admission for private entertainments that were outside the scope of public purposes but lost when the California Supreme Court determined

J Street view, the Sacramento Memorial Auditorium. *Tom Myers Photography.*

that, even if admission was charged, the erection of an auditorium still fell within young Sutter's "public use" provisions. Except for a ten-year closure from 1986 to 1996, Memorial Auditorium has been a venue for exhibits, concerts, inaugurations and high school graduation ceremonies since it opened in 1927. The immense landmark brick building, fronted by pilasters and ornately capped columns, is listed on the National Historic Register.

RECURRENT FLOODS AND THE SOLUTION: FOLSOM DAM

From Sacramento's birth in the heyday of gold frenzy, the destructive power of the unpredictable American River has inspired awe and dread. Despite laborious and costly levee construction, re-channelizing the river away from downtown and raising the business district after the great 1861–62 flood, devastating inundations recurred in 1878 and again between 1902 and 1909. The population explosion in the city and environs during the twentieth century, spurred by ever-expanding job opportunities and two world wars,

South Fork of the American River, near Coloma. *Photo by author.*

meant that there were even more lives, homes and businesses at risk. During the 1930s floods, motorists and pedestrians risked stalled-out engines and human limbs attempting to traverse city streets.

Preliminary engineering studies to erect a dam in the foothills above the town of Folsom began in the late 1920s, but the project was shelved during World War II. In 1944, Congress authorized the American River basin development as a flood-control project, providing for a reservoir of 355,000 acre-feet capacity. Under the leadership of Governor Earl Warren and others, this legislation was amended to provide a full one-million-acre-feet-capacity reservoir, irrigation of surrounding lands and a hydroelectric plant. Thousands of spectators lined the banks of the American River on Saturday, October 2, 1948, for official groundbreaking ceremonies that featured music by the 724th Air Force Band and crowd-wowing aerial flyovers.

While no one doubted the wisdom of flood control, residents in the twelve thousand acres designated as the reservoir—some of them landowners for five generations—spoke publicly of heartbreak when informed they were to be uprooted; financial compensation could not replace their long-held traditions and love of the land. The creation of this lake-reservoir also

meant the loss of old-time mining town locales. It is unknown how many of these settlements once existed within the tri-county sections now submerged beneath Folsom Lake. Sacramento County named Mormon Island, Red Bank, Maple Ridge and others. Mormon Island, that fabulous gold-strike site and flourishing town thirty miles above Sacramento whose existence contributed so much to the rise of transport and commerce in pioneer days, burned in 1856 and was never rebuilt. Prior to construction of the dam, Mormon Island Cemetery's one hundred or so graves were relocated.

Work progressed steadily, although the mighty American River fought back several times. On each of these occasions, cofferdams were washed out, and the rain-swollen river poured over the top of the uncompleted structure. The maximum flood churning downstream from the river's headwaters in the high Sierra, cresting at 210,000 cubic feet per second, occurred in November 1950; the most spectacular of these overtoppings occurred in late January 1954. The dam held its own, though, in December 1955, when record rains dumped thousands of acre-feet of water, creating the greatest river flow in recorded history—in turn almost filling the then-empty one million acre-feet reservoir in just a few days. Without judicious releases of 70,000 cubic feet of water per second through the spillways, Sacramento probably would have been under water.

Construction of the Folsom Dam and Reservoir—actually a series of various-sized barriers that would stretch for 4.9 miles if laid end to end—was completed in March 1956. Day-long exhibitions and formal dedication ceremonies took place on Saturday, May 5, 1956, observed by twenty-five thousand rain-dampened spectators. The main dam is 340 feet high and contains enough concrete to build a highway eight inches thick by 16 feet wide from the Oregon border to Bakersfield, California. The Nimbus Dam, seven miles downstream and completed in 1955, created Lake Natoma and functions as an afterbay to re-regulate the flow from Folsom Dam. Although both lakes provide popular year-round recreational facilities, Lake Natoma's more constant water levels offer more reliable water sports opportunities than its upstream sister lake. The Nimbus Salmon and Steelhead Hatchery, built to replace spawning areas destroyed during construction of the two dams, is a popular tourist attraction. The power plants directly below each dam furnish hydroelectric power to the Sacramento Valley.

The Folsom Dam was conceived and built to protect Sacramento from floods "for all time." However, that assurance of safety could be false, as human ingenuity continues to battle with the capricious forces of nature, and the "all time" 1950s optimism has been downgraded by the Corps of

The Folsom Dam. *Tom Myers Photography.*

Engineers to less than one hundred years. During a severe storm in 1964, the inflow into Folsom Lake exceeded the downriver levee capacity, and in 1986 nearly 500,000 people living in the vicinity of the dam faced the possibility of flooding when engineers were forced to open the spillway gates after peak flows into the lake. Downstream, the swollen American River rose to within feet of the H Street Bridge's deck, a heavily trafficked thoroughfare connecting eastern Sacramento neighborhoods with downtown. On July 17, 1995, a design flaw led to a spillway gate failure, causing an uncontrolled five-story cascade of water that drained almost 40 percent of the water in Folsom Lake. Luckily, no major flooding occurred.

Currently, a number of additional flood protection measures are in place, including construction of a $962 million Folsom Dam Auxiliary Spillway, designed to help the Sacramento region achieve a 200-year level of flood protection. Completion is expected in 2017. Until then, Sacramento remains vulnerable if conditions are just right. The hazard is greatest if a major warm spring storm causes rapid melt-off of an accumulated Sierra snowpack, sending torrents of water downstream from a steep watershed in the high country. Meteorologists predict that the 1861–62 "monster storms" that flooded the length of California and three neighboring states is an event to be expected every 200 to 250 years.

Modern Times

Many decades ago, hordes of expectant prospectors camped along the banks of the American River, searching for gold. The powerful watercourse has since been tamed, although not entirely curbed. The independent, pan-swirling gold miners disappeared, but the golden past merely retreated, waiting to be rediscovered.

Part IX

Reconstruction and Restoration

SUTTER'S FORT

Sutter's Fort was the first of Sacramento's historical locations to suffer neglect and ruin and the first to be restored. In 1848, the year of the gold discovery, the fort began a swift decline as Sutter's employees deserted him. From May forward, a steady stream of visitors—settlers from all over California and the Pacific Northwest, and travelers from Mexico, South America, Australia and Hawaii—passed through the only trading post within a day of the mines. They swooped in like locusts, stealing what was not nailed and bolted tight: spades, picks, shovels, provisions, boards, axes and even the forged bell that had come from Fort Ross.

During this time, Captain Sutter, whose finances were habitually precarious, rented rooms to merchants, saloonkeepers and flophouse hotel operators who cared nothing for the fort or its accoutrements. Renters haphazardly cut new windows in the central building and doors through the outer walls. In December 1848, Sutter sold the central building to partners Alden Bayley and Michael McClellan for $2,000 "in coin or gold dust at sixteen dollars per ounce Troy weight...in part payment for the Hotel property in Sutter's Fort." Sutter himself fled to his Hock Farm near today's Marysville in early 1849 and later had to sue his buyers for payment.

Sutter's Fort central building circa 1880s, before restoration. *Courtesy Library of Congress HABS CAL, 34-SAC, 57—17.*

Bayley, at least, purchased more of the fort property because in 1852 he offered to sell the "larger part of" the facility to the state for $5,000 for use—in his words—as a lunatic hospital, citing the attic and basement stories of the main building, plus the nine furnished rooms in the middle story (fit for immediate use), a large bake house and three storerooms in the rear of the building, two water wells on the grounds, a corral and three lots lying outside the walls. Bayley further assured his purported buyer that "a very small outlay" would "adapt the whole to the purpose proposed." The legislature took no action on Alden Bayley's offer.

After Sutter left, no one cared about upkeep. Frontier-style adobe required regular coating to keep the mud-and-straw bricks from deteriorating under winter rains and summer's brutal sun. Two of the last entries concerning routine upkeep, both jotted in May 1848 in the fort's business log known as *The New Helvetia Diary*, record sectional white washing (a paint concoction then made of milk and crushed lime). The eighteen-foot-high, three-foot-thick outer walls were the first to crumble and fall, as newcomers pried out loosened adobes to fill in the surrounding sloughs or to construct new accommodations. In time, the fort's gates were dismantled for building materials elsewhere, and its hand-hewn shingles sheltered newer rooftops. By 1855, only the central building and the southeast cannon bastion remained intact. Two years later, the bastion toppled.

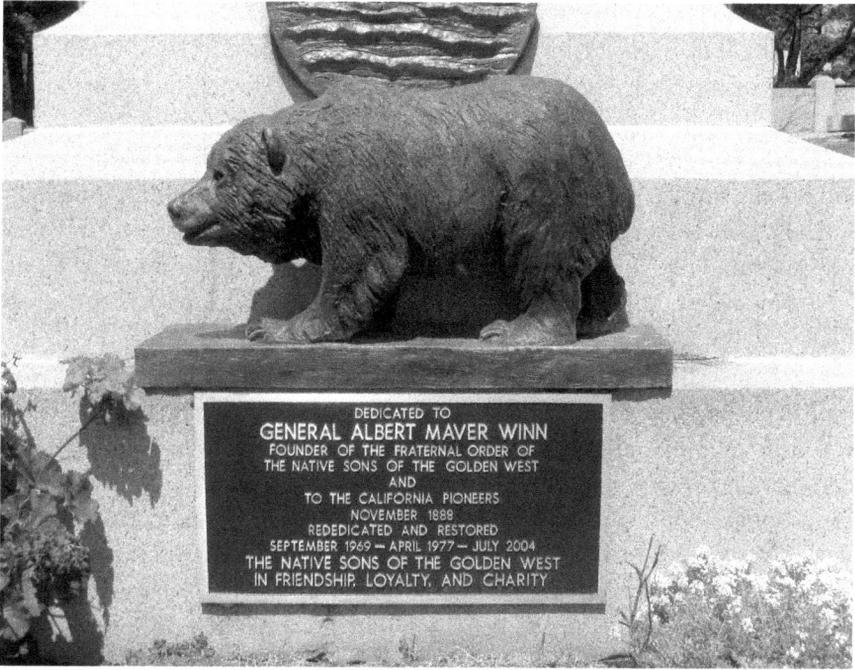

Memorial to Albert Maver Winn, Sacramento City Cemetery. *Photo by author.*

For over thirty years, the once impressive edifice sat in ruins, straddling two city blocks between Twenty-sixth, Twenty-eighth, K and L Streets. In 1881, a Convention of Pioneers met in Sacramento to discuss possible methods of honoring the memory of the recently deceased General Sutter: a simple monument, a memorial chapel or perhaps restoration of his fort. In 1887, the Women's Relief Corps proposed that Sacramentans invest in a fund as shareholders to purchase the property for a home for invalid military wives and widows and elsewhere on the grounds a "sort of museum" for the collection of artifacts of older times. Over time, Sacramento grew around the crumbled structure, grading and graveling streets in accordance with the original surveyed city grid map.

Forty-niner immigrant and Sacramento's first town council president Albert Maver Winn, now sixty-five and living in San Francisco, founded an organization for men who had been born in California. The Native Sons of the Golden West, whose mission was to preserve the state's colorful history as experienced by their pioneer ancestors, was formed on July 11, 1875. At the Native Sons' grand session in 1888, civil engineer C.E. (Carl Ewald) Grunsky, a Stockton native who had worked in the State Engineer's

117

Department at Sacramento for the previous six years, proposed that it was the duty of the Native Sons to restore Sutter's Fort. The membership agreed and established committees to begin fundraising efforts.

Then, in 1889, the Sacramento city board of trustees announced its intention to open Twenty-seventh Street through the old fort property, from K to L, an action that would result in obliteration of the dilapidated but still standing central building, and division of the plat into sixteen city lots. This notice unleashed a flurry of public interest in preserving the old relic, chiefly spearheaded by General (retired) James G. Martine of the state's Fourth Brigade, a well-known, civic-minded Sacramento citizen who had been employed for eighteen years by retail merchants L.L. Lewis & Co. Martine's first appeal in the *Sacramento Daily Union* in September 1889 commanded enough attention to rally newspapers editors to the cause and draw donations of $5 to $50 from individuals all over the state. Sacramento Parlor No. 3, Native Sons of the Golden West, subscribed $500 to the project and canvassed the neighborhoods to raise more. Mrs. Leland Stanford sent a check for $500, and Colonel Charles Frederick Crocker, son of the transcontinental railroad builder, subscribed $15,000. From Boston, the New England Association of California Pioneers sent $100 to the Sutter's Fort purchase fund.

Martine gained a statewide reputation for his persistent efforts. The obstacle confronting him, the Native Sons, and the Sacramento Society of California Pioneers, was the absentee landowner's apparent refusal to sell. A steady campaign of newspaper articles from coast to coast and personal entreaties directed at Benjamin Merrill of Chicago at last produced the desired result. According to the December 3, 1889 *Sacramento Daily Union*:

> *W. P. Coleman, agent for Mr. Merrill, yesterday called upon James G. Martine, who has taken the lead in the movement to preserve the old fort, and informed him that the owner…will sell* [the two blocks] *for the purpose named for the sum of $20,000, and would donate $2,000 towards restoring and preserving it. Mr. Merrill regretted that the newspapers had assumed that he was unpatriotic in declining to fix a price upon the property sooner. He considered the figure named a very low one and said he would not sell the property for the sum named for any other purpose, as he believed it was worth much more money.*

The purchased property was deeded to the Native Sons of the Golden West. Inspections and preliminary surveys commenced, under the supervision

of engineer C.E. Grunsky, who had recently executed improvements on the State Capitol grounds.

The intent was to restore the central building, rebuild the two bastions and reconstruct the north and east walls. The proposal included only stubs of the south and west walls, as the original southwest corner, built on a rise of ground in the wilderness many years before the city was ever contemplated, now jutted into the surveyed alignment of L Street. On April 22, 1891, the first bricks were laid in the new foundation of the central building by digging beneath the wall in five-foot sections and replacing the original foundation with fired red brick. When this was completed, the building was patched with new adobe bricks, manufactured with "old-time" methods insofar as possible. Next, work was started on the exterior walls (also fired clay brick, donated from an unknown source). The problem of the south and west walls was solved when the city realigned L Street to the south, donating the "abandoned" section to the Native Sons. Unfortunately, the only diagram and description of the original fort then extant contained numerous errors, the most notable being a shortening of the east yard by about 140 feet. A more accurate 1845 map of the fort was not rediscovered until the 1950s, but by then the east side had long since been graded below the original surface to a gentle slope where the Native Daughters of the Golden West had planted an extensive rose garden.

Although pioneer associations raised more money and the State of California appropriated $20,000 in 1891, the planners believed that there wouldn't be enough funds to rebuild the whole fort. In addition, all involved viewed their efforts as erecting a memorial to California pioneers, not a true period reconstruction. Compromises included reducing the exterior walls by three feet to make budget, moving in the north wall eight feet to accommodate a pond representing the original slough that ran behind the fort and accepting donated Spanish tiles for the roofs even though Grunsky knew Sutter's roofs were shaked. The contractor used adobe to reconstruct the interior rooms along the walls, and finally a fenced, whitewashed annex was added on the central building's north end to simulate Sutter's home in Switzerland. Gardens, trees and lawns were planted on the grounds outside.

The grand dedication ceremony took place on April 26, 1893. A procession of Native Sons from all over the state, four local military companies, members of the Pioneer Society and other citizens formed a column of carriages five blocks long starting from the Capitol, led by the Artillery Band. A cool breeze refreshed the marchers; American

Restored Sutter's Fort, west yard. *Photo by author.*

flags fluttered above the fort and from all the buildings in the vicinity. Thousands had already gathered inside and around the fort; as the procession drew near, cannons boomed out a salute. Representatives from the Native Daughters of the Golden West were escorted to their seats on a platform, and the rest of the afternoon and early evening was given over to introductions, congratulations, oratory and enthusiastic ovations. The celebration was perfect; disappointment came eighteen years later when General Sutter's descendants denied the Native Sons' request to remove his remains from the Moravian Cemetery at Lititz, Pennsylvania, and reinter them within the walls of the restored historical monument.

In subsequent years, Sutter's Fort was further rehabilitated. Many rooms were refurbished for the 1939 centennial celebration of Sutter's landing, and the large oak tree in the east yard, a gift from the municipality of Baden, Germany (John Sutter's birthplace), was planted. Sometime after World War I, the roofs over the distillery and interior corral were added to shelter the growing donated collection of wagons, documents, photos and paintings, tools and other nineteenth-century artifacts that once belonged to early pioneers. So many articles were housed there that the memorial was often referred to as "Sacramento's Attic."

The state accepted Sutter's Fort as a gift from the Native Sons in 1907; in 1947, it became an official unit of the California State Park system. Sutter's Fort State Historic Park celebrated the 100th anniversary of the pioneer memorial in 1993. Renovation and refurbishing of the structure, displayed artifacts and

surrounding grounds continue. Many of the historic "attic" artifacts are now housed in off-premises archives.

The historic icon that thousands of adults and schoolchildren visit annually is two-thirds its original size, primarily due to the "lost" footage outside the east gate. It is the first large-scale reconstruction/restoration of an adobe structure anywhere in the United States, the largest memorial dedicated to the memory of pioneers in America and the oldest state-operated museum in California.

In 1960, the California State Park Commission, in cooperation with the Sacramento County Historical Society and the Grand Parlors, Native Sons and Native Daughters of the Golden West, erected a bronze plaque near the corner of Twenty-eighth and L Streets to commemorate modern L Street's historical role as the gold rush–era Coloma Road:

> *Sutter's Fort, established by Capt. John A. Sutter in August 1839, marked the western end of the Coloma Road. Opened in 1847, this road ran from the fort to Sutter's sawmill at Coloma. Used by James W. Marshall in January 1848 to bring the news of the gold discovery to Sutter, it was traversed later by thousands of miners going to and from the diggings. In 1849 the Coloma Road became the route of California's first stageline, established by James E. Birch.*

CAPITOL MALL

Beginning in the 1890s, retailers, grocers, bakers, bankers, agricultural suppliers, churches, schools, restaurants and entertainments moved east and south of the original downtown, while shipping concerns and heavier industries remained close to the waterfront and rail lines. The larger commercial enterprises still dominated J and K Streets, while working-class frame dwellings and neighborhood businesses sprouted in several areas both west and east of the Capitol Building. In 1903, the city removed the R Street levee, allowing the surrounding neighborhood to develop as an industrial area. Middle-class residences and larger homes for the well-to-do rose on still-rural, unpaved streets east of Fifteenth from B to Broadway, some with hitching posts visible in 1913 photographs. That amenity soon became useless. By 1920, the popularity and subsequent social and economic impact of the

Historic Elks Tower on Eleventh Street. *Tom Myers Photography.*

automobile had replaced all service businesses related to horses with showrooms, gas stations, motor repair shops and tire dealers.

Sacramento's "new" downtown soon boasted a number of skyscraping structures to complement the landmark Cathedral of the Blessed Sacrament at Eleventh and K and the glittering dome of the Capitol Building. The earliest was the ten-story California Fruit Building about 1910, followed by the 216-foot-tall, pillar-design Cal-West Building at 926 J Street in 1925. The following year, the 226-foot-tall, Italian Renaissance–style Elks Temple opened at Eleventh and J. Other recognizable landmarks followed until the crash of 1929 closed the city's first high-rise era.

One consequence of all this eastward expansion was the decades-long decline of Sacramento's West End, principally the blocks closest to the Sacramento River waterfront. Over time, unkempt streets and vacant, absentee-owner buildings deteriorated into a sector of cheap bars and flophouses, transients and streetwalkers, considered a slum by most. During World War II, commanders of the outlying military bases forbade their young servicemen and women to enter the area, demanding that Sacramento officials "do something" to eliminate the blight. Nothing happened for many years.

Not all citizens considered their neighborhoods blighted—merely areas where working-class families drawn by job opportunities at

Sacramento's canneries and railroad shops could afford to live. Along the M Street corridor (Capitol Avenue by 1940), a mix of single-family homes, small businesses and proliferating billboards stood in place of 1860s-era multistory residences and the locale of that first, proudly billed 1859 Agricultural Pavilion. The Zanzibar Club, a popular jazz venue at 520 Capitol Avenue, opened in 1943. The Zanzibar, which began life in a former liquor store, featured touring musicians like Dizzy Gillespie, Count Basie and Duke Ellington. The Eureka Club at Fourth and K was considered one of the biggest nightclubs in northern California. These clubs and others like them became a major part of Sacramento's live music scene, drawing nightly crowds of all races and ethnicities. Acts that outgrew the jazz clubs played at the Memorial Auditorium.

In 1945, the hopes of futuristic-minded urban renewal advocates were encouraged by the passage of the California Redevelopment Act, which provided funds for improvement projects. Two years later, the Sacramento City Council voted to create a more impressive view for people entering the city from the west by removing the down-at-the-heels mixed neighborhood and widening the street between the Tower Bridge and the Capitol Building.

California State Capitol Building, southwest view. *Photo by author.*

Actual demolition and the start of reconstruction were delayed until January 29, 1957, when Sacramento mayor Clarence Azevedo and Governor Goodwin Knight presided at ceremonies marking the demolition of a dilapidated Victorian at 526 Capitol Avenue, the first building to officially succumb to the wrecking ball for the grand Capitol Mall Project. Completed in 1962, Sacramento's west-side Capitol Mall is a broad, well-lit boulevard with islands of grass at its center, lined with imposing, modern high-rise office buildings that are discretely set back behind richly foliaged trees to allow an unimpeded view of the Capitol.

OLD TOWN SACRAMENTO

In the interim, tentative plans were advanced for the rehabilitation and preservation of gold rush–era structures in the original city location near the Sacramento River, north of Capitol Avenue. Meetings between city, state and county officials and historical preservationists discussed a variety of options. Detailed studies commenced with the passage, in 1957, of a California statute authorizing the study of a zone of preservation in the historic West End.

One study, dated 1958, noted that seventeen (out of thirty-one) registered state historical landmarks in Sacramento County were located in Old Sacramento, defined as the zone bordered by Front Street, Third Street, I Street and Capitol Avenue. Some, like the B.F. Hastings Building at Second and J, the "Big Four" railroad tycoons' headquarters on K and the Adams & Company Building on Second Street, still stood, displaying the architectural styles of the 1850s to 1870s. Plaques marked the former locations of other places of historical interest. The study's recommended course of action was multifaceted: preservation and restoration of selected structures; reconstructed replicas where appropriate for use as commercial outlets such as shops, restaurants and offices; monuments to notable pioneers; development of a riverfront park; and prudent limits on vehicular traffic. Restoration costs were to be funded by the Sacramento Redevelopment Agency, other public coffers and private interests.

The sheer magnitude of the plans, and wavering public support, relegated the project back to committees for further study, as city leaders focused on other redevelopment needs: a shopping plaza near the Sacramento River

featuring Macy's as the anchor store, transformation of downtown streets into a pedestrian K Street Mall and complete rejuvenation of run-down sections along P Street. Macy's built its store in 1963, and the adjoining mixed enclosed and open-air plaza followed in 1971. A year later, the K Street Mall project was completed. Governor Jerry Brown presided over dedication ceremonies for Lincoln Plaza, a massive multi-block state office building at 400 P Street, in 1981.

Before most of the municipal renewal projects actively got underway, Caltrans' predecessor agencies had announced plans to construct a section of Interstate 5 through Sacramento—a town that as yet had no freeways. One proposal was to route the roadway west of the Sacramento River, in Yolo County; another was placement through Old Sacramento, thereby demolishing the historic district. Controversy erupted. Macy's executives, and other Sacramento business owners, were vehemently opposed to the West Sacramento route, citing a potential loss of business if the freeway bypassed downtown. Historians, preservationists and the *Sacramento Bee* equally vehemently argued that destruction of a quarter where gold rushers once trod, the first transcontinental railroad began and heroic city-raising preserved Sacramento's status as the state capital amounted to outright, foolhardy desecration. Eventually, a compromise was reached: Interstate 5's relatively short transit through town swerves east of Second Street.

The freeway route compromise saved twenty-eight acres of the city's birthplace, although part of Third Street was sacrificed and with it, among others, the original Stanford Brothers warehouse and the Huntington, Hopkins Hardware Store properties occupying much of the south side of K Street between Second and Third. Completed in the early 1970s, the freeway location proved a mixed blessing, for although it spared much of the district, it effectively cut off easy interaction with the rest of Sacramento, causing existing West End structures to sink into further neglect. Once more, ambitious plans took shape. Civil servants and private enthusiasts rallied. Old studies were dusted off and appended or revised.

The project cautiously moved forward. Time was allowed for architectural digs to unearth buried artifacts, for historians to "rediscover" ninetcenth-century drawings and photographs hidden away in various archives and for master craftsmen to study almost-forgotten design element techniques so that the restorations and re-creations would appear as authentic as possible.

The Firehouse Restaurant

Freeway construction was still in the land-clearing stage when Sacramento Buick dealer Newton Cope became the first private party to fulfill the West End project's "reservation for use" provisions. He purchased, gutted and refurbished Sacramento Engine Co. No. 3 on Second Street, in use as a warehouse at the time. Built in 1853, it was the oldest remaining firehouse in the city from that early day. Metropolitan-area Sacramentans and patrons from the Bay Area flocked to the Firehouse Restaurant when it opened in 1961, drawn by the novelty of posh dining in the middle of skid row. Named in Zagat's worldwide guide to "America's Top Restaurants," the award-winning Firehouse at 1112 Second Street remains a popular choice for fine dining, weddings and wine-tasting events.

The Firehouse Restaurant, the first restoration in Old Town Sacramento. *Photo by author.*

Reconstruction and Restoration

Major Undertakings

Isolation behind the emerging freeway hindered further progress in the district until the late 1960s, when the Sacramento Redevelopment Agency selected the old Morse Building at Second and K Streets, which had deteriorated significantly, for a demonstration of possibilities. One of its early owners was Dr. John Frederick Morse, a Vermont-born New York physician who settled in Sacramento in 1849 after a brief time spent gold mining at Coloma. Credited with co-founding Sacramento's first downtown hospital and tirelessly ministering to cholera victims in the 1850 epidemic, Dr. Morse was also the first editor of the *Sacramento Union*. Restoration of the Morse Building on the northeast corner of Second and K Streets was completed in 1969. Following this success, the Redevelopment Agency provided for future private development by installing modern utilities and rebuilding streets and wood sidewalks.

More restoration and reconstruction followed throughout 1972 to 1975: the Cavert and Booth Buildings on Front Street, the Heywood and Adams Express Company Buildings on Second Street and the Lady Adams at 113–15 K. Produce dealer M.L. Cavert erected his brick structure at 1207 Front Street about 1855; later, it was utilized as a Pacific Railroad storehouse. Newton Booth, governor of California from 1871 to 1875 and U.S. senator from 1875 to 1881, lived and entertained above his business, the largest wholesale grocery firm on the West Coast, at 1015–21 Front Street, for many years. Joseph Heywood erected a two-story brick building at the southeast corner of Second and J in 1857. His nineteenth-century tenants included the National Gold Bank of D.O. Mills and Leland Stanford's Pacific Mutual Life Insurance Company. Adams Express Company at 1014 Second Street was the first to use California granite in its building construction. Occupied over the years spanning 1853 to 1882 by Adams & Company, James Birch's stage company's headquarters and Wells Fargo & Company, the Adams Express Building also housed agents for the Pony Express from May to October 1861.

The Lady Adams Building, one of few that escaped Sacramento's Great Fire of 1852, is the oldest-surviving building in Sacramento except for the central building inside the walls of Sutter's Fort. This building on the north side of K Street and its next-door neighbor, the Howard House, were purchased and restored by the nonprofit Sacramento Trust for Historic Preservation. The three-story Howard House is but one example of the challenges faced in learning old techniques to accurately re-create 1850s exterior building details, such as cornices. The complex moldings on the Howard House were done in place in wet plaster, an almost lost skill.

Restoration details, the Howard House. *Photo by author.*

A replica of the Eagle Theater, constructed during 1974–75 at its original location, stands at the edge of an open grassy area east of Front Street. The original structure was a cloth house: canvas walls and ceiling stretched over a wood frame. The Eagle, Sacramento's first theater, opened in the fall of 1849 to nightly capacity crowds of clapping, whistling and sometimes jeering gold miners who regularly patronized performances by noted thespians of the time. Too fragile to withstand surging waters, the Eagle Theater collapsed in the flood of 1850.

With several years of restoration work still ahead, the 3,800-pound bronze statue commemorating the Pony Express was installed at the corner of Second and J Streets in 1976. The fifteen-foot-high statue of horse and rider, sculpted by Thomas Holland, took over two years to design and build. Casting and finishing was provided by Vianello Art Bronzes. The rider's saddle and specialized mail bag were modeled after originals in the Santa Barbara Historical Museum. The rider's clothing is based on a paragraph in Mark Twain's *Roughing It*, except for the wide-brimmed hat. The real Pony riders usually wore skull caps.

The first western terminus of the Pony Express was the B.F. Hastings Building at the southwest corner of Second and J, also home at various times to offices of the Sacramento Valley Railroad, the state attorney general, the State Supreme Court, Wells Fargo in 1854–1857 and the California State Telegraph Company. Benjamin Franklin Hastings completed the partially finished building he bought at a sheriff's sale in March 1853, opening his bank, Hastings & Company, a month later. In the early months of his ownership, Hastings leased street-level space to two clothing merchants. Restoration of the building began in 1975. The B.F. Hastings Building was officially dedicated as a unit of the California State Parks Department on March 17, 1976.

The Big Four Building

Not to be left out, although the original structures were razed to accommodate Interstate 5's route, was the historically valuable Big Four Building complex, the combined Huntington, Hopkins and Company

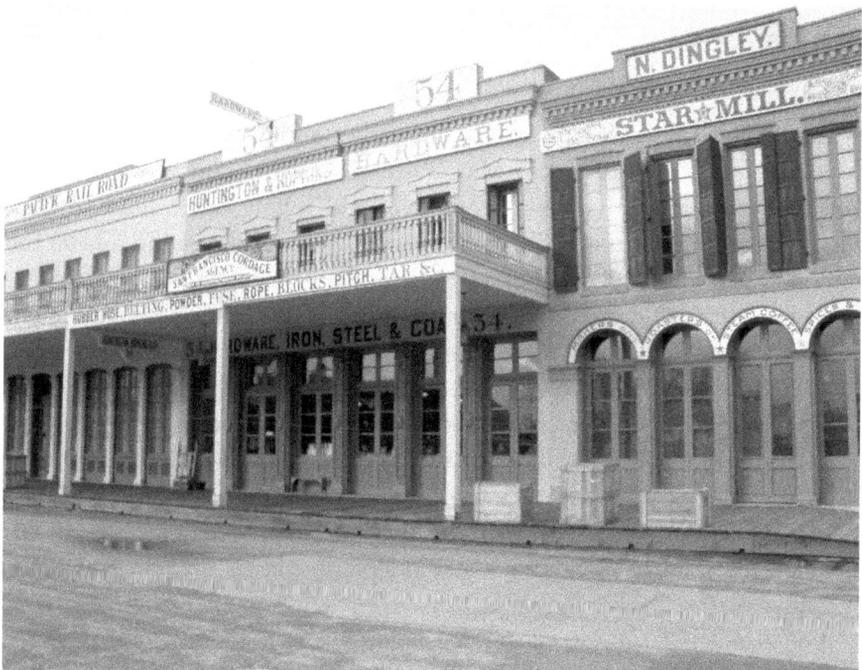

Replica of the Big Four Buildings and the Dingley Steam Coffee & Spice Mill Building in Old Sacramento. *Photo by author.*

Hardware Store and the Stanford Brothers warehouse that once stood side-by-side. A replica of the Stanford Brothers warehouse, whose second floor housed the famed Central Pacific headquarters where Sacramento merchants turned railroad moguls plotted each mile of the first transcontinental railroad, now stands at the corner of Front and L Streets.

A site suitable for a replica of the Huntington, Hopkins Hardware Store was agreed on in 1965, next to the historic (although relocated) Nathaniel Dingley Steam Coffee and Spice Mill on I Street. Little is known of Dingley's life or establishment, other than that he settled in Sacramento in mid- to late 1850, buying out a partner in the coffee and spice business. More is known of the Huntington, Hopkins Hardware Store, in its heyday a bustling retail operation selling mining supplies, blasting powder, dredging machinery and ordinary iron goods like nails, hinges and kettles. Opened as an exhibit in 1981, the hardware store's ground floor holds displays of nineteenth-century tools and machinery. Upstairs are the general offices of the California State Railroad Museum, a re-created Central Pacific Railroad boardroom and the museum's library reading room. The façades of both buildings were refurbished with new paint colors and signage in 1998.

California State Railroad Museum

A few steps away is the modern, multistory, 100,000-square-foot Railroad Museum building. Opened in May 1981, the facility contains a stunning collection of genuine vintage locomotives and rolling stock, model trains, dioramas and numerous exhibits illustrating the impact of railroads on the nation's economy and the lives of its people. The entire California State Railroad Museum covers much more ground. The Central Pacific Freight Depot, reconstructed in 1986 and currently used as the passenger station for the Sacramento Southern Railroad's excursion rides along the levees of the Sacramento River, is just north of the spot at Front and K Streets where groundbreaking for the Central Pacific Railroad (CPRR) took place in January 1863. North of the freight depot is a faithful reconstruction of the CPRR Passenger Station as it appeared in 1876, complete with an old-time telegraph office, baggage room and separate "ladies and children only" waiting room.

The very first CPRR passenger facility was a mere wooden shack quickly assembled by frugal Collis Huntington. In August 1867, his partner Mark Hopkins applied for permission to erect a much larger,

one-story frame depot, expanded by 1870 to include a refreshment stand. Arriving passengers were regularly accosted by runners and "hackmen" employed by nearby hotels, each insisting his porter services, his carriage or his hotel was superior to all others.

City Hall and Waterworks (Site): Sacramento History Museum

One of Sacramento's first public-use buildings, the City Hall and Waterworks, was designed to answer the need for a better water supply system made evident by the catastrophic 1852 fire. Completed in 1854, the two-story brick and reinforced beam structure, just north of the intersection of Front and I Streets, supported three water tanks on its roof, along with a network of pumping machinery and pipes. The interior housed offices for city council members, volunteer firefighters and the city jail and police court.

In the late 1860s, the railroad installed tracks and a turntable close by. The weight of the tanks ultimately took their toll, and city-raising efforts between 1863 and the early 1870s left the building in a depressed hole, further compromising the gravity-fed distribution method. By July 1873, a

Sacramento History Museum, housed in the reconstructed 1854 Waterworks and City Hall Building. *Photo by author.*

newer pumping system was in operation, installed in an adjacent building. Constant vibration from the trains further affected the already weakened City Hall and Waterworks, creating serious concern for the safety of its occupants. The weakest forty feet at the building's west end were razed in 1880 and the water tanks reworked. Still, by the turn of the century, the building obviously required extensive renovation, and the Southern Pacific wanted the property for a right of way to expand its freight-handling facilities. The rooftop tanks and connections were abandoned when the city sold the property to the railroad in 1906, on condition of continued use while a new jail was constructed elsewhere. Seven years later, the Southern Pacific demolished the building.

A red brick re-creation opened in 1985 at 101 I Street as the home of the Sacramento History Museum. Faithful in design to the original, the exterior accouterments include brick walks and a 113-foot flagpole topped with a gilt ball. Inside, visitors walk through modern chrome and glass galleries filled with diverse exhibits.

Other Restoration

The Old Sacramento Schoolhouse, re-created in the style of the one-room schools in the Sacramento Valley in the mid-1800s, welcomes inspection at the south end of Front Street, a little north of where a replica of the *Globe*, a two-masted vessel converted to a floating storeship during the gold rush, bobs against pilings near the Tower Bridge. Current-century bartenders serve wine and spirits in a newer version of Our House Saloon on Second Street. Signage identifies the former sites of the Magnolia Saloon, the What Cheer House, the Fashion Saloon and other gold rush–era public houses, hotels, mercantiles and warehouses. In all, over fifty structures dating from Sacramento's origins have been restored, reconstructed or re-created—more than in any other city in California. The National Park Service named this entire area a National Historic Landmark in 1965. Few buildings are in their original use; most house restaurants, gift emporiums, jewelry stores, antiques vendors and souvenir shops.

Although it wasn't part of the ambitious project, the refurbished *Delta King*, a steam-powered paddle-wheeler that plied the Sacramento and San Joaquin Rivers from 1926 to 1941, is permanently docked at the riverfront as a popular floating hotel and dining, entertainment and wedding venue.

An estimated five million locals and tourists visit Old Sacramento State Historic Park every year, drawn by the annual Music Festival (formerly Jazz

The *Delta King*, docked permanently at Old Sacramento's riverfront since 1984. *Photo by author.*

Jubilee), Gold Rush Days celebration, New Year's Eve events, the *Delta King*'s ambience and the chance to experience a ride in a horse-drawn carriage. A placard on Front Street reminds sightseers that the Sacramento waterfront was an exciting, chaotic place in the 1850s, where hundreds gathered daily to trade trail-worn livestock or bid on East Coast merchandise recently shipped around Cape Horn, all too often mesmerized by the popular actor-auctioneer and social gadabout Stephen Massett, who boasted that he could sell a one-dollar mouth harp for a chunk of gold worth eight dollars.

SACRAMENTO FOUNDER AUGUST SUTTER (JOHN JR.) BROUGHT HOME

Intense and nervous by nature, exhausted by wily merchants' intrigues and family squabbles, genuinely ill from a malady that might have been malaria and kept in a state of drugged acquiescence by an unscrupulous doctor who

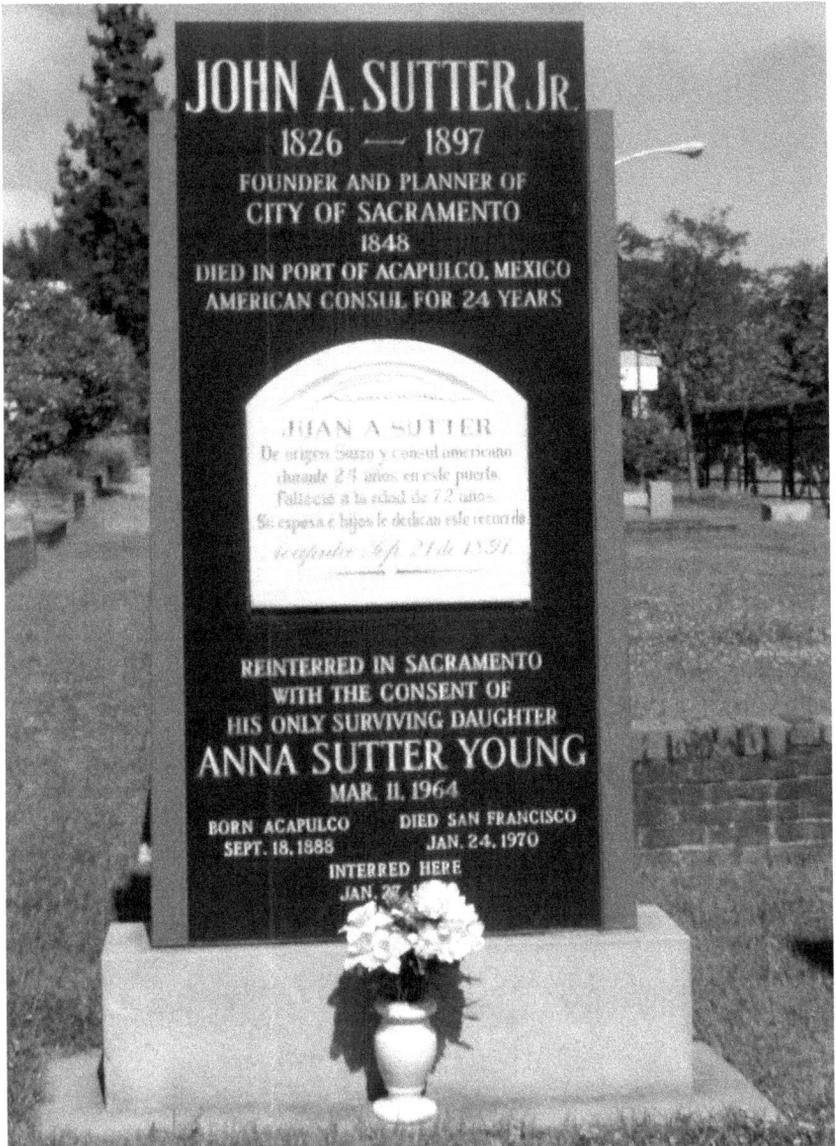

Memorial grave marker of August (John Jr.) Sutter in Sacramento City Cemetery. *Photo by author.*

had inveigled himself into the young man's confidence as a "best friend," August Sutter fled California in July 1850. Headed for Panama, he instead left the ship at the little Mexican port of Acapulco, where he decided to stay ashore while Dr. Brandes continued on to Panama. Once parted from

his physician, August's head miraculously cleared. He settled in Acapulco and eventually prospered as a merchant. He married twice, fathering twelve children. In 1870, August Sutter was appointed as the first U.S. consul to Acapulco, a post he served in with honor for seventeen years, retiring in 1887. He died on September 21, 1897, aged seventy, and was entombed in the Panteon Municipal Cemetery in Acapulco.

Sixty-six years later, Acapulco officials announced plans to demolish this cemetery to make more room in the now-booming seaside tourist town, notifying descendants of the deceased that they would need to arrange for reinterment elsewhere. Mrs. Anna Sutter Young, August Sutter's only surviving daughter, then living in San Francisco, sent a plea to the Sacramento County Historical Society requesting its help in returning her father's remains "to their rightful resting place" in Sacramento.

In March 1964, appropriate ceremonies at Acapulco attended the removal of August Sutter's remains, which were placed in a flag-draped coffin for the sea journey to Long Beach, California, aboard the U.S. destroyer *Leonard Mason*. From there, Sacramento and Mexican officials escorted the coffin via U.S. Navy aircraft to Sacramento.

On Wednesday, March 11, 1964, local and foreign dignitaries reinterred John A. Sutter Jr. in Old City Cemetery on Broadway, with about thirty of his descendants from San Francisco to Mexico City on hand, as well as Mayor Ricardo Morlett of Acapulco and other Mexican dignitaries; representatives of Governor Edmund Brown, Sacramento County Historical Society, City-County Chamber of Commerce, Native Sons and Native Daughters of the Golden West; and members of the Historic Landmarks Commission. Former Sacramento mayors served as pallbearers.

Tentative plans for permanent burial closer to the waterfront, beneath a grander grave monument, never materialized. Sacramento's founder still rests in the cemetery his father gifted to the city in 1849, that tumultuous year of the California gold rush that catapulted fledgling Sacramento—born of a wilderness trading post's river landing—to prominence as the enduring capital city of California.

Bibliography

Akahori, M. B., ed. and pub. *Early History of California and Its Development into a State*. Pamphlet. Los Angeles, ca. 1931.

Armstrong, Lance. "East Sacramento's McKinley Park Has Rich Heritage as East Park." Valley Community Newspapers, Inc., February 16, 2012.

———. "Famous Fabulous Forties Neighborhood Is a Gem of East Sacramento." *East Sacramento News*, September 3, 2009.

Avella, Steven M. *Sacramento: Indomitable City*. Charleston, SC: Arcadia Publishing, 2003.

Barber & Baker, Engravers. *Sacramento Illustrated*. San Francisco: Monson & Valentine, Steam Book and Job Printers, 1855.

Blenke, Joe A. "The Story of Folsom Dam, Folsom, California: Official Souvenir Program Folsom Dam Dedication." 1956.

Bone, Pam, horticultural advisor. University of California Cooperative Extension, Sacramento.

Burg, William. *Sacramento*. Charleston, SC: Arcadia Publishing, Then & Now Series, 2007.

———. "Sacramento's Bourbon Street." *Golden Nuggets* newsletter, March 2012. Sacramento County Historical Society.

———. "Sacramento's First Skyscraper." Reprinted from *Midtown Monthly*, 2009.

Burns, John F., and Richard J. Orsi, eds. *Taming the Elephant: Politics, Government, and Law in Pioneer California*. Berkeley: University of California Press, 2003.

California State Department of Parks website(s): Old Sacramento SHP; Governor's Mansion SHP; Folsom Dam.

Carroll, Ed. *Sacramento's Breweries*. Golden Notes 53, no. 1 (2010).

Cutter, D. S. & Co., comp. and pub. *Sacramento City Directory, for the Year A.D. 1860; Being a Complete General and Business Directory of the Entire City*. Sacramento, CA: H.S. Crocker & Co., Book and Job Printers, 1859.

Davis, Hon. Winfield J. *An Illustrated History of Sacramento County California*. Chicago: Lewis Publishing Company, 1890.

Day, Rowena Wise. "Carnival of Lights." *Golden Notes* 16, nos. 2 and 3 (July 1970).

de Courcy, Sean McBride. "McKinley Boulevard Tracts One & Two Historic District Survey." Master's thesis, California State University, Sacramento, Fall 2010.

Demas, Marilyn K. "Ungraded School No. 2—Colored: The African American Struggle for Education in Victorian Sacramento." *Golden Notes* 45 (Spring and Summer 1999).

Helmich, Stephen G. "Sacramento's 1854 City Hall & Waterworks." *Golden Notes* (Winter 1985).

Historic Landmarks of the City and County of Sacramento. Pamphlet. Friends of the Sacramento City and County Museum, 1976.

Holden, William M. *Sacramento—Excursions into Its History and Natural World*. Fair Oaks, CA: Two Rivers Publishing, 1988.

Holliday, J.S. *Rush for Riches: Gold Fever and the Making of California*. Copublished by the Oakland Museum of California and the University of California Press. Copyright 1999 by J.S. Holliday.

Hudson, Jeff. "In Deep." *Comstock's*, June 1998.

Hurtado, Albert. *John Sutter: A Life on the North American Frontier*. Norman: University of Oklahoma Press, 2006.

Kelly, John. "The Chronology of Sutter's Fort." Legacy of John Sutter papers, Sutter's Fort State Historic Park Archives.

Kibbey, Mead B., ed. *J. Horace Culver's Sacramento City Directory for the Year 1851*. Sacramento: California State Library Foundation, 2000.

———. *Samuel Colville's Sacramento Directory for the Year 1853–54*. Sacramento: California State Library Foundation, 1997.

Kyle, Douglas E., ed. *Historic Spots in California*. 5th ed. Stanford, CA: Stanford University Press, 2002.

Lewis, Donovan. *Pioneers of California*. San Francisco: Scottwall Associates, 1993.

McClay, Patrick L. "Joyland. Sacramento's Coney Island Streetcar Park." *Sacramento Magazine*, March 1986.

McCoy, Dennis. "Sneak Peek: Progress at the Folsom Dam Spillway." *Sacramento Business Journal*, April 27, 2012.

McGowan, Joseph. *A History of the Sacramento Valley*. Vol. 1. New York: Lewis Historical Publishing Company, 1961.

Myers, Tom. *Sacramento. Postcard History Series*. Charleston, SC: Arcadia Publishing, 2010.

Ostrander, Gilman M. "The Prohibition Movement in California, 1848–1933." *University of California Publications in History* 57 (1957).

Ottley, Allan R. "The Founder of Sacramento." *Golden Notes* 9, no. 4 (October 1963).

Ottley, Allan R., ed. *The Sutter Family and the Origins of Gold Rush Sacramento*. Norman: University of Oklahoma Press, 2002. Copyright 1943, Sacramento Book Collectors Club.

Parkman, E. Breck. *A Fort by Any Other Name: Interpretation and Semantics at Colony Ross*. Santa Rosa: California Department of Parks & Recreation, February 1992.

Sacramento Archives and Museum Collection Center and the Historic Old Sacramento Foundation. *Old Sacramento and Downtown*. Charleston, SC: Arcadia Publishing, 2006.

———. *Sacramento's Midtown*. Charleston, SC: Arcadia Publishing, 2006.

Sacramento County Historical Society. "The Railroad Shops 1863–1950." *Golden Notes* 19 (November 1973).

"Sacramento's Tower Bridge." Bgpappa.hubpages.com.

Scott, James, and Tom Tolley. *Sacramento's Alkali Flat*. Special Collections of the Sacramento Public Library. Charleston, SC: Arcadia Publishing, 2010.

Severson, Thor. *Sacramento An Illustrated History: 1839 to 1874 from Sutter's Fort to Capital City*. California Historical Society, 1973.

Society of California Pioneers. *New Helvetia Diary—A Record of Events Kept by John A. Sutter and His Clerks at New Helvetia, California, from September 9, 1845, to May 25, 1848*. San Francisco: Grabhorn Press, 1930.

Taylor, Jeanne Sturgis, trans. "Golden Nugget's San Francisco County Biographies: Albert Gallatin." Freepages.genealogy.rootsweb.ancestry.com.

Thompson, Willard. "Prince of Sacramento." Sacramento Magazine 2, no. 9 (September 1985).

Vaught, David. Cultivating California: Growers, Specialty Crops, and Labor, 1875–1920. Baltimore, MD: Johns Hopkins University Press, 1999.

Zollinger, J. Peter. Sutter the Man and His Empire. Gloucester, MA: Peter Smith, 1967. Copyright 1939 by Oxford University Press, Inc., New York.

Newspapers

California Farmer and Journal of Useful Sciences, August 24, 1860.

Pacific Rural Press, November 18, 1916.

Placer Times, April 6, 1850.

Sacramento Bee, October 1, 1952; January 18, 1970.

Sacramento Transcript, October 21, 1850.

Sacramento Union, November 17, 1851; November 4, 1852; December 8, 1853; April 11, 1854; July 14, 1854; January 29–30, 1855; February 3, 1855; February 18, 1856; February 25, 1856; May 19, 1857; March 19, 1859; October 25, 1859; June 12, 1860; July 3, 1860; May 25, 1861; June 14, 1861; January 9, 1863; February 2, 1863; April 8, 1865; January 1, 1866; October 25, 1866; June 2, 1869; June 11, 1869; July 24, 1871; November 30, 1872; March 6, 1874; January 19, 1878; April 18, 1883; May 28, 1883; January 1, 1887; April 27, 1893; July 15, 1895; July 22, 1895; September 9, 1895; September 11, 1895; September 25, 1899; March 8, 1964; plus various January 1881–December 1889.

San Francisco Call, September 23, 1891.

Index

About the Author

C heryl Anne Stapp published her first short story in the *Sacramento Bee* at age eleven. She is the author of numerous magazine articles and *Disaster & Triumph: Sacramento Women, Gold Rush Through the Civil War*, a history of pioneer women who settled in California's capital city. She lives with her husband in Sacramento, where she is a member of the Board of Directors of the California Writers Club, Sacramento Branch. See her website "California's Olden Golden Days" at http://www.cherylannestapp.com.

Visit us at
www.historypress.net

www.ingramcontent.com/pod-product-compliance
Lightning Source LLC
Chambersburg PA
CBHW060807100426
42813CB00004B/979